Art copyright © Hergé/Moulinsart 2007
Text copyright © Michael Farr/Moulinsart 2007

American edition © Last Gasp 2007
ISBN-13: 978-0-86719-690-0
Printed and bound in Belgium

Published by Last Gasp of San Francisco
777 Florida St San Francisco, CA 94110
www.lastgasp.com

First published in English in 2007 by Egmont UK Limited
239 Kensington High Street, London W8 6SA

MICHAEL FARR

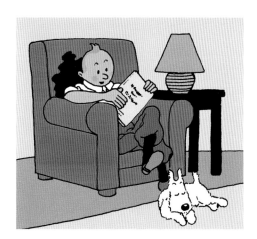

# TINTIN & CO.

LAST
GASP

# ACKNOWLEDGEMENTS

I would like to dedicate this book to Kelly Wingfield Digby (1952–2004) who provided invaluable technical assistance, having already helped with my previous book, *Tintin: The Complete Companion*. He was of the generation that first discovered *The Adventures of Tintin* as, one book after another and out of sequence, they were skilfully translated into English by the formidable duo of Leslie Lonsdale-Cooper and Michael Turner. A true Tintinophile, he could rank among his many distinctions an ability to read Tintin in Icelandic.

I also remember affectionately Sabine Astheimer (1956–2004) with whom I first read Tintin (or Tim as he is known in Germany, in German). Professor Cuthbert Calculus, or Professor Balduin Bienlein as he is in the German editions, would certainly have cultivated a rose for her.

Stefanie Jordan, who became a friend of Hergé's brother Paul Remi, the original model for Tintin, helped as she has done in all my previous books by providing fascinating original material. Born in 1913, she well exceeds the recommended '7 to 77' reading range.

The idea for this book was spurred by Caroline Knox, and encouraged by Didier Platteau of Moulinsart in Brussels. Like any book on Tintin, it draws on the indispensable *Entretiens avec Hergé* of Numa Sadoul – no volume offers greater insights into Hergé or his creation. I am also indebted to Philippe Goddin, Belgium's leading authority on Hergé. At the Studios Hergé, I must thank, above all, Bernard Tordeur, who over the years has provided every kind of assistance, and Dominique Maricq for helping track down material from the archives.

I must applaud Michel Bareau and Louise Cliche – worthy successors to the original artists of the Studios Hergé – for the brilliance of their art direction and graphic design, Agnès Roisse for her patient coordination of the project and Ivan Noerdinger for its promotion. Mark Rodwell, who represents Moulinsart in Britain, merits special praise for his good humour and ready assistance. At Egmont, credit is due to Sharika Sharma for her keen editorial eye.

Finally, I must thank Fanny and Nick Rodwell for their vital support, ideas and advice.

# CONTENTS

# INTRODUCTION

The twenty-three completed and one unfinished book that make up *The Adventures of Tintin* are fast-moving but highly detailed stories, brimming over with excitement, humour and subtlety. Based very accurately though never pedantically on the closely observed world around us, they allow our imagination to soar, our pulse to quicken.

Hergé's enduring success as an author is based on his obviously brilliant drawing and the less apparent but equally important strength of his narrative. Each adventure is a thriller but only because of the careful thought and preparation that went into its construction.

Although early on, in the manner of the silent cinema, there was sometimes a haphazard, improvisatory feel to the narrative as week by week it advanced as a newspaper comic strip – Hergé admitted that sometimes on a Tuesday he would not know how Tintin could be extricated from his latest scrape or tight corner in time for the Wednesday deadline – by the time of *The Blue Lotus* (begun in 1934, published in book form 1936) the adventures were as carefully constructed as any symphony. When Hergé was in a mood to discuss Tintin – which was by no means the whole time, often he tried desperately to get away from the hero he had created – he would hypothesize about his characters and future situations they might find themselves in.

Apart from constantly collecting and filing away visual material such as newspaper articles, photographs and postcards for possible future use, Hergé kept exercise books at hand where he could jot down ideas, observations and names for incorporation in the adventures. For example, searching for a suitable Christian name for Captain Haddock, he noted almost 50 possibilities before favouring Archibald. Among the more unusual names he jotted down were Attila, Jeremiah, Horace and Marmaduke which he deemed 'too radical'. It was a laborious process but one that clearly paid dividends.

Hergé adopted a similarly thorough approach to his drawing after the considerable spontaneity and freedom of the opening adventures, especially *Tintin in the Land of the Soviets* which Hergé later resisted transforming into a colour edition like the others, considering it to be to some extent 'a sin of his youth'. He would sketch sometimes furiously in pencil until he was satisfied that he could ink over the drawing. Each individual frame and its relation to the ones preceding and following was carefully considered, adopting a method more familiar to the film-maker than the graphic artist.

Proof of his diligence and quality of composition is that any frame – or, to use the film analogy, 'still' – can be highlighted or enlarged and looked at in isolation and stand as a work of art in its own right. It did not need the American pop artist Roy Lichtenstein, an admirer of Hergé's work, to point this out. Lichtenstein himself went on in his distinctive manner to portray Tintin in his favourite red armchair. The appreciation was mutual and Hergé acquired a sequence of Lichtenstein's screen prints inspired

by Monet's Rouen Cathedral series, which he hung in his Avenue Louise office, where they can still be seen. Hergé's enthusiasm for modern art embraced another celebrated American contemporary artist, Andy Warhol, who executed a sensitive screen print portrait of him in the style of the better-known portraits of Marilyn Monroe and Jackie Onassis. Hergé met Warhol in New York and again in Brussels.

So in *The Adventures of Tintin* Hergé married his considerable graphic gifts to a strong narrative, but this in turn was underpinned by his brilliant cast of characters: 'Tintin and co.', or 'la famille Tintin' as it has long been known as in French. It was not enough to have just Tintin and Snowy as in the first three adventures. However compelling this engaging pair was, readers would eventually tire of their breathless exploits. Depth was needed and that could only come with a supportive cast, as well devised and drawn as the original protagonists.

Hergé began this process, ultimately the key to the continuing popularity of the adventures, in *Cigars of the Pharaoh* (1934) where readers for the first time encounter the arch-villain Roberto Rastapopoulos, the hopeless Thom(p)sons and the inestimable Portuguese merchant, Senhor Oliveira da Figueira. Next, in *The Blue Lotus*, there is the crucial meeting with the real and the fictional Chang followed by the unexpected and dramatic reappearance of Rastapopoulos after his apparent demise in the previous adventure, in a twist reminiscent of Conan Doyle and *The Return of Sherlock Holmes*. *The Broken Ear* brings us the explosive and enduring figure of General Alcazar, a ruthless yet affable Latin American dictator in an operetta-like military uniform. The Teutonically sinister Müller first appears in *The Black Island*, and the magnificent leading lady – prima donna assoluta – of *The Adventures of Tintin*, Bianca Castafiore, in *King Ottokar's Sceptre*.

The most important and popular addition came in the next adventure, *The Crab with the Golden Claws*, with the first appearance of Captain Haddock, and then, three stories on, in *Red Rackham's Treasure*, Professor Calculus. Not surprisingly, both were to remain permanent members of the company. Among principal members of the cast, that left the delinquent Prince Abdullah to make his boisterous debut in *Land of Black Gold* and the impossible Jolyon Wagg to enter blithely in *The Calculus Affair*.

It was a hundred years before Hergé first thought of Tintin, in 1828, that the French writer Honoré de Balzac (1799–1850) wrote the first novel to be published under his own name. At the time he was unaware that he was beginning the great epic work of his age, *La Comédie humaine*, ultimately comprising over 40 novels. It was as he wrote one novel after another that he discovered the value of creating characters that could reappear in this vast and ambitious portrait of society and of 19th century manners. Character repetition brought cohesion, continuity and heightened reader interest.

Balzac thus devised an ingenious system of 'reappearing characters' where readers are liable to meet, sometimes to their surprise, the same persons again in different novels. Hergé created Rastapopoulos a hundred years later, in much the same manner that Balzac invented his master-criminal, Vautrin. Like Balzac, Hergé palpably took pleasure in his great villain who added a sense of melodrama to proceedings. In neither case was their scheme or plan preconceived; it evolved and of its own accord became a key to the books.

We know from letters and interviews that Hergé read Balzac's novels, particularly during the 1950s, and was especially struck, in his own words, by 'a fascinating book', *Balzac et son monde* by Félicien Marceau, published in 1955, which fully revealed to him the brilliance of *La Comédie humaine* and the value of recurring characters. Even though he had already started the process in the mid 1930s, the reading of Marceau's book spurred him further, and in October 1956 he embarked on *The Red Sea Sharks* where, inspired by Balzac's example, he was to assemble, in addition to the regular protagonists, a record number of familiar characters: General Alcazar, Abdullah and his father the Emir Ben Kalish Ezab, Sheik Bab El Ehr, Dawson, the crooked former police chief in the International Settlement in Shanghai, Senhor Oliveira da Figueira, Dr Müller alias Mull Pasha, Allan, by now promoted from First Mate to Captain, Bianca Castafiore, Jolyon Wagg and last and certainly not least, the irrepressibly evil Rastapopoulos, here masquerading as the Marquis of Gorgonzola.

There is a similar rallying of forces in the ultimate but unfinished *Tintin and Alph-Art*, where Hergé planned to bring back a whole range of characters from earlier adventures. If only for this reason, the final adventure promised much. Of course, modest as ever, Hergé would not have himself mentioned in the same breath as the great French novelist.

While readers are in turn thrilled, amused and captivated by the adventures, it is the characters that are best loved and remembered. Let us then have a closer look at Tintin and co. and explore how the principal characters came into being and developed over the years, vitally holding together and embellishing Hergé's *Adventures of Tintin*. As Tintin invites readers on the cover of *The Castafiore Emerald*, let us quietly sit back and review the cast before enjoying their performance.

# TINTIN

# Without relatives and of indeterminate age, an intrepid young man of high moral standing, with whom everyone can identify.

The first appearance of Tintin. Frame from *Tintin in the Land of the Soviets*.

**T**intin, the unbeatable hero of the adventures that bear his name, is a celebrity who most unusually can combine worldwide fame with a discreet, little-known origin and private life. In that respect, as well as others, he is remarkably like his creator, Georges Remi, better known as Hergé.

Hergé created him hurriedly in January 1929 to help fill the pages of *Le Petit Vingtième*, a weekly children's newspaper supplement he was charged with editing, still aged only 21. Emulating a quality soon to become a strength of the character he was about to create, Hergé had to perform some quick thinking.

## PRECOCIOUS AT DRAWING

Georges Prosper Remi – Hergé was derived from the reversal of his principal initials, as pronounced in French – was born in Brussels on May 22, 1907. From an early age, Georges took to drawing in his notebooks and in the margins of his school exercise books. One of his favourite subjects during those difficult years of the Great War (1914–18), when his home city of Brussels was under German occupation, was, according to his own accounts, a boy hero battling *les Boches* (slang for the Germans), carrying out acts of sabotage and spying. Unfortunately no such juvenilia survive.

## PRECURSOR OF TINTIN

A few years later, reflecting his considerable enthusiasm for scouting – the highlight of a childhood which he described to the Paris newspaper *Le Monde* in February 1973 as "very grey" and of which, "of course, I have memories, but these do not begin to brighten, to become coloured until the moment when I discovered scouting" – he created a Boy Scout character called Totor that he drew for the magazine *Le Boy-Scout belge* in the manner of a strip cartoon, a relatively new form of expression in Europe though well established in America. Using speech bubbles containing the odd word punctuated generously with exclamation and question marks, it was the beginning of the modern strip cartoon.

## HERGÉ, JACK OF ALL PAGES

Hergé's natural ability at drawing was noticed at *Le Vingtième Siècle* where in his first proper job after leaving school he was initially employed in the subscriptions department. He soon found himself being asked to provide drawings and vignettes for different parts of the paper, whether women's fashions for *Votre "vingtième" Madame* or

illustrative scenes for the arts and book pages, at a time when newspapers used fewer photographs. His all-round usefulness as an illustrator led Father Norbert Wallez, the priest who was the Catholic newspaper's director, to put him in charge of a supplement for children that would be published every Thursday. When pondering what he should do for *Le Petit Vingtième*, he had Totor very much in mind and this indomitable Scout was in every respect the antecedent for Tintin: in appearance, in resourcefulness, as a do-gooder and even in the catchy alliteration of the name.

The reporter Albert Londres, one of the models for Tintin.

## TINTIN, THE BEGINNINGS OF AN ADVENTURE

Tintin was to take all Totor's inherent qualities further from the moment of his first appearance on January 10, 1929, setting out by train from Brussels for a hazardous adventure in a country in turmoil, the Soviet Union. Tintin, Hergé later told Numa Sadoul, was to some extent "the little brother of Totor, a Totor turned journalist yet always keeping the spirit of a Boy Scout."

Hergé did not have much time to think about his new character. The improvisatory aspect of Tintin, notably the simplistic drawing: a round head, a button for a nose and two dots for eyes, the quiff to be – a few strokes of the pen – was to be the very key to his character's instant success. He was flexible, distinctive yet anonymous: any child, or even adult, could readily identify with him; age and culture were irrelevant.

Hergé in 1949.

## FROM ALBERT LONDRES TO TINTIN

Working in a busy newspaper office was a stimulating experience for the young Hergé who was highly receptive to ideas, fascinated by current affairs and topics of the day, and had a keen eye for visual detail. Like any journalist, he benefited from the newspaper cuttings library before creating an archive of his own which he was to maintain to the end of his life and that provided the essential raw material for his work on the adventures. He was always abreast of the latest news, having access not only to Belgian but also to foreign newspapers. The American press provided him with up-to-date examples of strip cartoons as they had developed across the Atlantic. Amid such excitement, Hergé could dream of becoming a famous reporter himself, a celebrated foreign correspondent like Albert Londres, who not only reported but created news.

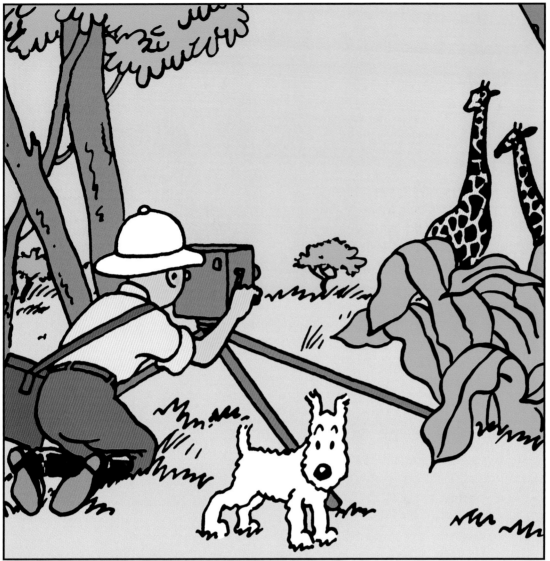

Frame from *Tintin in the Congo*.

Londres perished on the liner *Georges-Philippar*, which in 1932 sank in the Red Sea after a mysterious fire, as he returned to Europe with the promise of an undisclosed scoop. When it came to a hero for the new children's supplement, why not have a reporter–adventurer like Londres? So Tintin came into being, representing the reporter that Hergé would himself have liked to be.

In an interview with *Lire* magazine in December 1978, Hergé admitted that through Tintin he was able to experience the life of a reporter. He could – and pressure of work demanded that he did – remain in Brussels, an armchair traveller, as he sent Tintin to almost every corner of the world. Tintin initially sets out with camera and notebook to complete his reportages for *Le Petit Vingtième* but we rarely see him file his copy. There is a unique moment in *Tintin in the Land of the Soviets* where we spot him writing a despatch much longer than any editor would want.

In the next adventure, *Tintin in the Congo*, the budding reporter – suitably for the subject – proves himself a proponent of photo-journalism, filming giraffe, buffalo and other African wildlife.

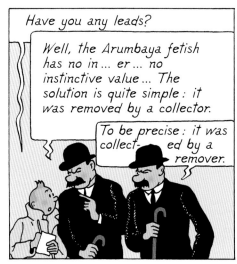

Frame from *The Broken Ear*.

## FROM REPORTER TO EXPLORER

As the adventures continued, it is newspaper articles about – though not by – Tintin that multiply. In the original version of *The Blue Lotus*, the very first plate is a newspaper report entitled "Des Nouvelles de Tintin" ("News about Tintin") giving an account of the state of affairs at the conclusion of the previous adventure (*Cigars of the Pharaoh*) signed with the initials G.R. – obviously Georges Remi. In the later English edition this is replaced by a simple, non-newspaper résumé. Finally, the Shanghai News has a front-page story about the rescue of Professor Fang Hsi-ying and the arrest of the drug ring under the headline "Tintin's Own Story," an interview signed by a reporter with the initials L.G.T.

We catch Tintin exercising his profession again in a scene at the Museum of Ethnography in *The Broken Ear* where, notebook in hand and in the company of another reporter as well as the Thom(p)sons, he questions the cleaner and the museum director about the theft of the fetish.

Elsewhere it is more usual for Tintin to be quizzed, such as at the end of *The Black Island*. "Welcome back, sir. Can we have a few details? Your own words …" the radio reporter asks before the press pack flees at the sight of Ranko the gorilla. In *Land of Black Gold*, Tintin goes to interview the managing director of Speedol and poses the proper journalistic questions. Only the lack of note-taking is unjournalistic.

From being an investigative reporter Tintin develops into a detective. Snowy and others refer to him regularly as Sherlock Holmes and he has a good deal of the famous English detective about him – including a sharp eye for detail, considerable powers of deduction and an ability to solve conundrums. Like Holmes, Tintin is a master of disguise, and in Rastapopoulos he finds his own arch-enemy, pitted against him as relentlessly as Moriarty was to Conan Doyle's hero.

As the adventures progress, moreover, Tintin embraces wholeheartedly the role of the explorer, culminating in his most memorable achievement – the first steps he took on the Moon, some 16 years before the American astronaut Neil Armstrong.

Frame from *Land of Black Gold*.

Frame from *The Broken Ear*.

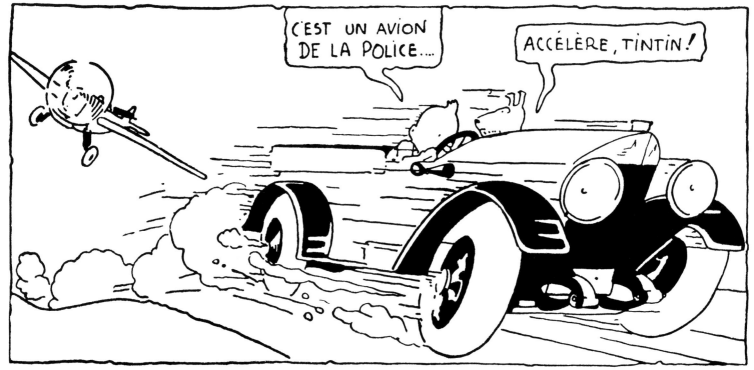

Frame from *Tintin in the Land of the Soviets*. The development of the hallmark quiff.

Paul Remi, Hergé's younger brother.

Tintin had ceased to report news and instead was making it. "Tintin is myself. He is my most luminous reflection, my successful double. I am not a hero. But like all 15-year-old boys I have dreamed of being one … and I have never stopped dreaming. Tintin has accomplished exploits in my place," Hergé told *Le Monde* in February 1973.

## PAUL, BROTHER AND MODEL

While there was a good deal of Hergé in the reporter–hero he had created, particularly the Boy Scout ethos, the high morality and ingenuity, he had a particular model in mind, certainly for Tintin's physical appearance: his brother Paul.

"People say that I look a little like my hero. Or that Tintin looks like my younger brother," Hergé said in an article in *Le Soir* in December 1940. "That's possible … All I can say is that during my childhood I had as a playmate a brother who was five years younger than me. I observed him a lot. He amused and fascinated me. And that, no doubt, is the explanation why Tintin borrowed his character, his gestures and attitudes." Furthermore, Tintin's most obvious feature, the quiff, which stayed with him from that moment in *Tintin in the Land of the Soviets* when the reporter put his foot down on the accelerator of the S-type Mercedes-Benz he has car-jacked from the Berlin police, was also inherited from Paul Remi.

## NAME, FIRST NAME: TINTIN

Hergé never explained why he chose Tintin as the name for his reporter–hero. It was the first name that stuck in his mind and clearly he liked the alliteration, as in Totor. Tintin is his surname, something we know from references to him as Mr Tintin, as well as the name on the doorbell of his flat at 26 Labrador Road. The explanation must be Hergé's recollection of a childish character, Tintin-Lutin, created around 1900 by the children's author Benjamin Rabier. Hergé acknowledged familiarity with the illustrator's work and the influence on his own drawing of Rabier's beasts, notably the farm animals that fail to be intimidated by Snowy's torn tiger outfit in *Tintin in the Land of the Soviets*: "It's true. When I was young I admired Benjamin Rabier enormously. And I had such a recollection of his drawings that I must have thought of them when drawing my animals. That is to be seen undeniably!"

Rabier's Tintin-Lutin is a small boy who has a quiff and, judging by the daily punishment meted out by his father, is a mischievous monkey who is suitable material for a cautionary tale. While the noun 'tintin' means a tinkle or clink (of glass, for example), 'lutin' is an imp in French.

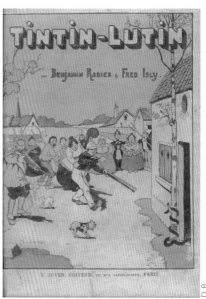

Tintin-Lutin, the character created by Benjamin Rabier.

## AN AGELESS HERO

The next question posed by Tintin is his age. The answer in brief is that he remains a young (teenage) reporter throughout, despite the passage of some 50 years and the mass of experience gained, or else he is as old as each reader thinks. In 1970, Hergé attempted to give an answer: "For me, Tintin hasn't aged. What age do I give him? I don't know … 17? In my judgement, he was 14–15 when I created him, Boy Scout, and he has practically not moved on. Suppose he put on 3 or 4 years in 40 years … Good, work out an average, 15 and 4 equals 19."

Detail from *Tintin in the Land of the Soviets*.

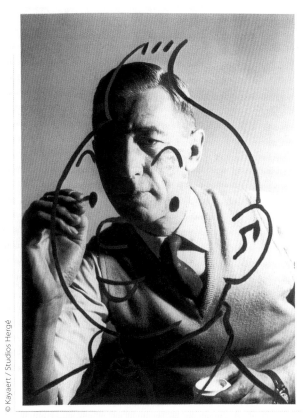

© Kayaert / Studios Hergé

Hergé in 1958.

Detail from
*Tintin and the Picaros*.

## TINTIN, THE DRAWING

Unlike some of the other characters in *The Adventures of Tintin*, the reporter hardly develops. In the first two or three adventures he is still somewhat gauche, more a well-meaning Boy Scout than a budding reporter. The drawing too is cruder, freer and sometimes more poetic in *Tintin in the Land of the Soviets* and *Tintin in the Congo*, but by the time he arrives in Chicago in the third adventure both he and Hergé have gained in confidence, and readers too feel they know the reporter well. From then on, he was to change little in either appearance or dress.

The only concession to modern times comes in the final completed adventure, *Tintin and the Picaros* (1976), where he changes out of his familiar plus-fours or knickerbockers into slightly flared, brown jeans, a mistake in the opinion of many readers which was ultimately acknowledged by Hergé. With the possibility of Hollywood at the time becoming interested in making a Tintin film, the plus-fours, so fashionable 50 years earlier, were regrettably discarded. One of Tintin's hidden strengths, it was to become apparent, was that his appeal was beyond fashion, in strip cartoon terms it was classic. There was therefore no need to make him more 'with-it' as Hergé did in the *Picaros* by changing him into jeans and sticking a ban-the-bomb sticker onto his motorcycle helmet. Asked by Numa Sadoul how the character Tintin developed after *Land of the Soviets*, Hergé replied: "He practically did not evolve. Graphically he remained an outline. Look at his features: his face is a sketch, a formula. Quite different to Captain Haddock's more mobile, expressive face, signalling a much more intense life."

Frame from *Tintin in the Land of the Soviets*.

## TINTIN, THE COMPLETE ALL-ROUNDER

Like Ian Fleming's later, Royal Navy-trained agent James Bond, there is no car, motorcycle, locomotive, boat or submarine, aeroplane or helicopter that Tintin cannot drive, steer or fly with panache – he drives a Japanese armoured car in *The Blue Lotus*, a specially adapted tank on the Moon and a main battle tank in Borduria. In *Tintin in the Land of the Soviets*, using a pocket knife, he is able to cut and carve an aeroplane propeller from a tree. Similarly, in *Cigars of the Pharaoh* he fashions a wooden trumpet with which to communicate with the elephants. As the first man on the Moon, he proves himself a highly adept and courageous engineer and scientist. He is also a skilled radio operator with a good knowledge of Morse code.

Frame from *Cigars of the Pharaoh*.

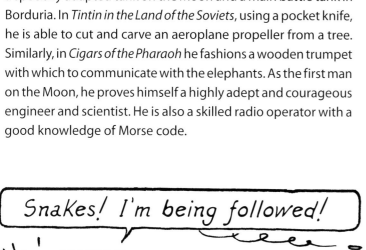

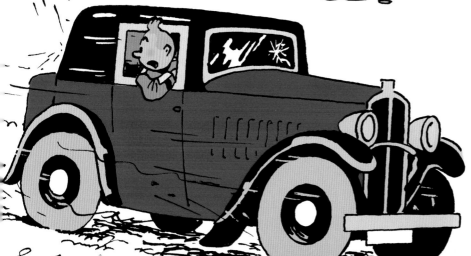

Detail from *The Broken Ear*.

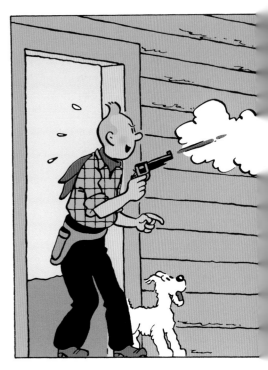

Frame from *Tintin in America*.

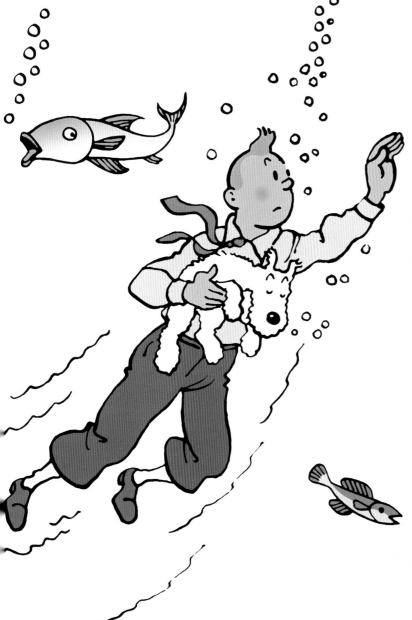

Detail from *Tintin in the Congo*.

## SWIMS LIKE A FISH

As well as his fighting skills, Tintin is a strong swimmer, capable of diving into the shark-infested sea to rescue an unconscious Snowy in *Tintin in the Congo*, or pulling Chang from the flooded river in *The Blue Lotus*. In *The Crab with the Golden Claws* he swims fully clothed through the choppy sea to come up and surprise the aviators repairing their seaplane, while in *Prisoners of the Sun* he swims to the anchor chain of the Pachacamac to sneak aboard. In *The Calculus Affair*, Tintin fishes the cab driver from the water after their taxi has been forced off the road into Lake Geneva.

## TINTIN THE CRACKSHOT

Readers know from *Tintin in the Congo* that he is a crackshot, accumulating an excessive tally of game, as hunters were in the habit of doing at the time (the early 1930s). A succession of wild animals are also neutralised in *Prisoners of the Sun* – a condor, a boa constrictor and a number of alligators – but this time to save Snowy, Zorrino and Captain Haddock rather than just for sport. In *Tintin in America* he shoots the bottle – with which he is about to be struck – out of Bobby Smiles's hand. In *The Crab with the Golden Claws* Tintin can bring down an aircraft with a single shot and then puts on a masterful display pinning down the Berber raiders in the desert. There is no doubting his ability with a revolver, an automatic – generally a Browning, though he picks up a German Lüger in *The Black Island* – or a rifle. He could compete at Bisley.

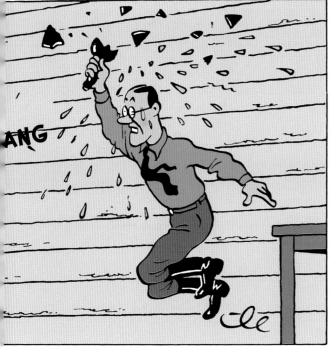

Detail from *The Castafiore Emerald*.

## A BEACON OF EXCELLENCE

The point about Tintin is that he is an all-rounder, good at almost everything, which is what Hergé himself would have liked to be, but above all honest, decent, compassionate and kind, as well as modest and self-effacing, which Hergé certainly was. He is also the loyalest of friends, which Hergé strove to be.

There is perhaps a bit of Tintin in all of us and certainly our lives are punctuated by moments and situations that can truly be described as Tintinesque. Hergé created a hero who embodied human qualities and virtues but no faults, even if the reporter lets himself become rather too tipsy before facing the firing squad in *The Broken Ear*. He has tremendous spirit and in *Tintin in Tibet*, where this is best exemplified, the monk Blessed Lightning appropriately gives him the name Great Heart.

*The Adventures of Tintin* mirror the past century while the reporter himself provides a beacon of excellence for the future. For any child setting out in the troubled 20th century Tintin was a suitable role model. Readers of first *Le Petit Vingtième*, then *Le Soir* and finally *Tintin* magazine, or the two dozen books of the adventures that were published over some 50 years, could do no better than follow the reporter's inspiring example – and be delighted at the same time. He remains an inspiration and pleasure in the 21st century, for readers old and new, of all ages – much wider than his declared range of 7 to 77 – both sexes and in more countries even than the many to which he managed to travel in his extraordinarily eventful, globe-trotting career. It is – "Great snakes!" – a remarkable achievement. ▮

# SNOWY

# Courageous yet easily frightened, boastful but modest, Tintin's faithful companion.

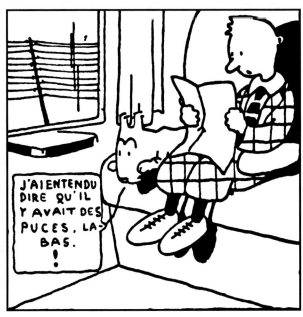

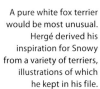

Snowy and his master on the way to Moscow.
Frame from *Tintin in the Land of the Soviets*.

A pure white fox terrier would be most unusual. Hergé derived his inspiration for Snowy from a variety of terriers, illustrations of which he kept in his file.

**S**nowy is rather more than a pet dog, he is Tintin's faithful and resourceful companion, traversing continents with the reporter–adventurer and saving his life on numerous occasions. He is a canine hero capable of seizing the initiative, whether taking on a lion in the African bush or neutralising explosives by lifting his leg on the fizzing fuse. This was the first dog on the Moon, in a specially designed space suit.

## THE CHOICE OF BREED

When Tintin first set out in the world on his trip to the Soviet Union in the pages of the children's supplement *Le Petit Vingtième* on January 10, 1929, Snowy was at his side, where he was to remain until the end came with Hergé's death in March 1983. Through 24 adventures, reporter and dog are inseparable. They survive any number of tight corners and scrapes where the end seemed nigh, and on one occasion (*Cigars of the Pharaoh*) there is the tragic picture of Snowy prostrate, weeping on his master's 'grave' like Greyfriars Bobby. Hergé chose a fox terrier as Tintin's canine companion, unusually all white. In 1929 and during the early 1930s, this was very much the breed of the moment. The fox terrier was popular for its pluck, character and intelligence – attributes abundantly evident in Snowy.

Hergé did not own a dog until the last months of his life, but he would occasionally borrow one!

## SOURCES OF INSPIRATION

There were no fox terriers in Hergé's family. However, the landlord of the café-restaurant to which journalists of *Le Vingtième Siècle* would adjourn for drinks and meals was the proud owner of one – partly the inspiration for Snowy. When Tintin came back from his first adventure in the Soviet Union, a huge welcome party was organised at the Gare du Nord station in Brussels as a publicity stunt for the newly created and instantly popular character. A young man with a likeness to the reporter was found and dressed in Russian costume and the café owner's fox terrier was borrowed as Snowy. The reporter and his dog were mobbed and the venture was a great success.

To his English-speaking readers Tintin's dog is well-known as Snowy, the name alighted on by Leslie Lonsdale-Cooper and Michael Turner, Hergé's solidly reliable English translators, as a safe choice for such a white fox terrier. The name Hergé chose in French, however, was rather more original: Milou. This happened to be the name of Georges Remi's first serious girlfriend, Marie-Louise Van Cutsem, known to her friends as Milou, a diminutive for Marie-Louise. Almost two years older than Georges, she was an object of romantic fascination for him and excited his adolescent years. He had hopes that their friendship would lead to something more, but her father, who worked for the celebrated Belgian *art nouveau* architect Victor Horta, considered the young Remi, son of a boy's clothing outfitter, to be unsuitable and came to discourage their meetings. Though hurt, Hergé retained a soft spot for Milou and when it came to finding a name for his newly created hero's fox terrier and loyal companion, he could do no better than choose that of his former flame.

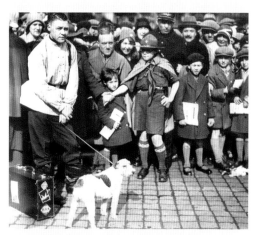
Tintin's triumphal return from the Soviet Union, enacted at the Gare du Nord in Brussels on May 8, 1930. Photograph from Hergé's archive.

Marie-Louise Van Cutsem in 1919. Known as Milou, Hergé's first girlfriend inspired the French name for Tintin's faithful fox terrier. Photograph belonging to Hergé.

## A RATHER BOASTFUL MALE

The origin of Snowy's name in French might be considered to cast doubt on his sex. Could the terrier be female? However, an examination of Snowy's behaviour in the adventures makes it pretty obvious that he is a boy and that there is no cause for any radical rethinking of his gender. Two examples clearly underline his masculinity: the episode on board the Aurora when he cocks his leg on the smouldering stick of explosives (*The Shooting Star*) and a less well known moment in the unfinished *Tintin and Alph-Art* when he makes a pass at Bianca Castafiore's black miniature poodle – "How do you do, Madam …" he thinks and then directly makes the advance: "Hello, beautiful!" – succeeding only in frightening her off, yapping, overcome by such familiarity. His bravado and bragging throughout the stories and his fear of any medical treatment (*Tintin in the Congo*) are also typically male.

There is the wonderful scene in the second frame of the African adventure where he swanks to all the sundry breeds of dog who have assembled to listen: "Yes, I'm going after lion, of course, that sort of hunting holds no secrets for me!" Then, of course, French being an unambiguous language when it comes to sex, we know from the start that Milou (Snowy) is male from the use of 'il' (he).

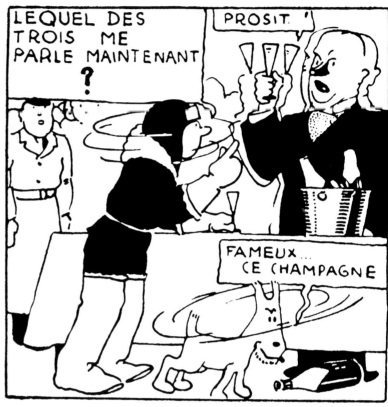

Frame from *Tintin in the Land of the Soviets*.

Detail from *Tintin in the Land of the Soviets*.

## CELEBRITY . . . AND VANITY

Throughout this hurried and action-packed first adventure to Russia, Snowy chips in with canine comments, injecting the necessary humour. He at once makes himself both endearing and indispensable, as well as displaying characteristics – his partiality to alcohol and his vanity – to be developed later. When Tintin lands in Berlin and is mistaken for a dashing South to North Pole aviator, he receives a hero's welcome, is carried through the throng shoulder-high and fêted with champagne. Snowy finds a not quite empty bottle on the ground. "Good, eh!" he comments before adding dizzily: "Jolly good champagne." It ends in the fox terrier's first hangover. As for vanity, there is a fine display on the penultimate page of the adventure as they near home. Tintin produces a comb and mirror and perfects his quiff. "Tintin! . . . Such vanity! . . . Aren't you ashamed?" Snowy observes, before taking up the comb, admiring himself in the mirror and applying the brush vigorously to his flank.

Frame from *Tintin in the Land of the Soviets*.

## GREEDY GUTS!

During the course of this first adventure there is also ample evidence of this dog's delight in food, drink and slumber that is to be a *leitmotif* throughout the series. As Tintin sights Berlin, Snowy's first response is: "At last! Now to eat and drink and sleep." He is not disappointed as Tintin enters the Gasthaus *Zum Löwen* (The Lion Inn) and together they are seated at a table and given a meal of Teutonic portions, with plenty of sausages and bones for Snowy and a large Stein of beer for the reporter. "How lovely to have a proper dinner!" the ravenous dog remarks. "Snowy, don't eat too much …" his master warns.

His gourmandise or sheer greed is well illustrated in the tenth adventure, *The Shooting Star*, notably on page 23 where he lies contentedly asleep, his stomach seriously distended by the string of sausages he has consumed. Nine pages on, Snowy has an entanglement with a large pot of spaghetti. "Dratted animal! … Wait till I catch him," declares the ship's cook.

Generally, like most healthy dogs, he will eat anything, with chicken a particular favourite. Snowy consumes a whole bird with ease, taking due care with the delicate bones, in *Red Rackham's Treasure*. He has greater difficulty with the cooked chicken he finds at the scene of the airliner crash in *Tintin in Tibet* for the simple reason that it is frozen solid.

Frames and detail from *Tintin in Tibet*.

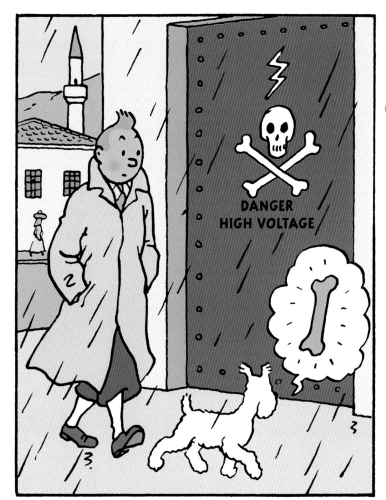

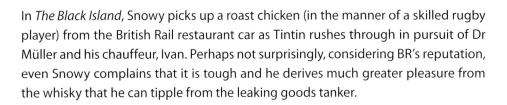

Frame from *King Ottokar's Sceptre*.

Detail from
*The Crab with the Golden Claws*.

Detail from *Tintin in Tibet*.

Detail from
*Tintin and the Picaros*.

In *The Black Island*, Snowy picks up a roast chicken (in the manner of a skilled rugby player) from the British Rail restaurant car as Tintin rushes through in pursuit of Dr Müller and his chauffeur, Ivan. Perhaps not surprisingly, considering BR's reputation, even Snowy complains that it is tough and he derives much greater pleasure from the whisky that he can tipple from the leaking goods tanker.

When Tintin first meets Haddock in *The Crab with the Golden Claws*, Snowy has the nerve to drink directly from the blubbering Captain's glass of whisky. The Captain is too lachrymose to notice. It marks an unofficial pact between Tintin's two closest companions: Snowy would in future talk less but share the Captain's love of liquor.

**TASTY TEMPTATION**

Alcohol apart, there is nothing Snowy likes better than a good bone and he will go to some lengths to obtain one. The most extreme choice – and no doubt the least juicy – is the huge dinosaur bone he retrieves from the Natural History Museum in Klow (*King Ottokar's Sceptre*). Snowy has bones on the brain and when he spots the reinforced door of an electricity sub-station bearing the inscription "DANGER HIGH VOLTAGE" and a skull and crossbones, he immediately visualises a tasty, if elusive, bone. Snowy becomes the real hero of this adventure when at its conclusion he retrieves the royal sceptre that has fallen from Tintin's coat pocket. There is, however, a wobble when he spots an appetising bone lying in the road. Faced with a very difficult decision for a

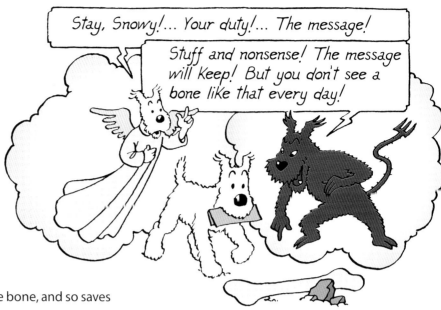

Detail from *Tintin in Tibet*.

dog, he chooses to bring the sceptre back, leaving the bone, and so saves the day – which does not stop him thinking of that bone . . .

A question of such existential choice is later raised again in *Tintin in Tibet* where Snowy, running off with the SOS message scrawled by Tintin, sees a magnificent bone in his path and grinds to a halt. The angel and devil images of his conscience appear. This time Snowy succumbs to the over-powering canine weakness for bones. Earlier he is delighted to find a wide selection of bones in the yeti's cave: "Golly, this old yeti keeps a well-stocked larder!" On the final page of this adventure about friend-ship, Tintin, Chang and Haddock trek across the Himalayan expanse back to Nepal. Snowy follows with an outsize bone he has picked up from the skeleton of a large beast.

Detail from *King Ottokar's Sceptre*.

Years earlier, in *The Blue Lotus*, Snowy, bone in mouth, strolls happily with Tintin on the ship's deck. In *The Black Island*, Snowy digs up a decent bone that he refuses to give up for four pages until it is wrenched from him by Dr Müller's formidable Great Dane. However, he gets the better of a larger dog in *King Ottokar's Sceptre* when with Tintin he surprises the Bordurian frontier post at lunch and snatches a bone from in front of the nose of an Alsatian. On the first page of *The Crab with the Golden Claws*, hoping for a bone, he rummages in a dustbin and gets his snout stuck in an open tin of crabmeat. Later, after Tintin and Haddock crash-land in the Sahara, Snowy quickly finds a king-size bone from the skeleton of a camel. Then on the final page, in a delightful touch, Tintin opens his door to the postman bearing a large parcel for Snowy – inside is a magnificent bone tied with a pink ribbon and accompanied by a note in the manner of a Valentine, "To Snowy, from an admirer."

There is just one occasion when Snowy has no appetite for bones or food. He is so distraught when Tintin flies off without him to search for the meteorite in *The Shooting Star* that all Haddock and the crew's efforts at consolation with dog delicacies are to no avail. Snowy continues to howl until he sees Tintin returning.

Frame from *The Shooting Star*.

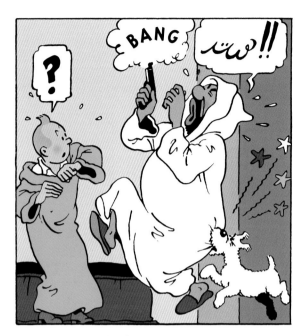

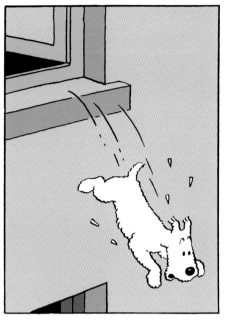

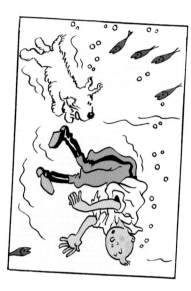

In *The Crab with the Golden Claws* Snowy jumps up at Omar Ben Salaad and gets a good bite of his rump.

In *The Secret of the Unicorn* he courageously jumps from a first-floor window in pursuit of Tintin's captors.

## SNOWY FEARS NOTHING … EXCEPT SPIDERS

While Snowy can bluster with bravado, there is no doubting his bravery on numerous occasions from the first adventure onwards. He is essentially a heroic character, particularly when his master is threatened. He is a fighter with typical terrier traits, undeterred by bigger, fiercer dogs, lions, cheetahs, goats, gorillas or evil humans. Tintin can depend on his characteristic canine loyalty and sometimes surprising initiative, whether neutralising high explosives or repeatedly freeing him from his bonds. Snowy, a true fox terrier, is both courageous and intelligent. He has a sure instinct, seeing through the guise of dubious characters sooner than his master. He is, moreover, stubborn and tenacious – further characteristics of his breed. In fact, Snowy fears nothing except spiders, even if he has some unfortunate tangles with parrots, a species for which Hergé had an enduring fascination.

Snowy is a thinking dog whose thoughts are caught in speech bubbles. He comments on the exploits of Tintin, sometimes ironically, or else urging caution, reflecting his own fears. This incredible terrier understands human language, comes to sensible conclusions, takes an interest in mechanics in *Tintin in the Land of the Soviets* and geography in *Cigars of the Pharaoh*.

Snowy is a strong swimmer. In *The Broken Ear* he brings a stunned Tintin to the surface of the piranha-infested river.

Detail from *The Black Island*.

He knows his Bible in *Tintin in the Congo*, where he refers to the judgement of Solomon as well as the story of David and Goliath. Luckily, he is also a true dog who sniffs, scents, tracks, chases, bites and barks . . . "Wooah! Wooah!"

## HADDOCK, A THUNDERING RIVAL

Only Tintin, however, can converse with him and after the arrival of the voluble Captain Haddock in *The Crab with the Golden Claws*, Snowy has less to say. After eight adventures as Tintin's co-star, the faithful terrier is upstaged by the blustering, choleric Captain with his extraordinary repertoire of expletives and weakness for the bottle. Snowy had shared the limelight exclusively with Tintin for over 10 years, now it was time for Haddock to edge him aside. No longer does this remarkable dog engage in a constant dialogue with his master, or offer a running commentary on developments. He no longer commands the same focus of attention. It is a loss for Snowy, but a gain for the adventures that are enriched by the presence of the Captain who reflects one side of Hergé's own character as much as Tintin does the other.

Snowy enjoys comfort and the move to Marlinspike Hall with its grand rooms, extensive park and the countryside clearly suits him, even if he suffers occasional reverses in his tussles with the resident Siamese cat. Despite the chases, dog and cat do, however, strike up some sort of rapport as is charmingly portrayed in the last frame of *The Calculus Affair*.

Snowy certainly has a great many admirers: a recent survey in France showed that after Captain Haddock and Tintin, he was the third most popular character in *The Adventures of Tintin*. What a dog! ▪

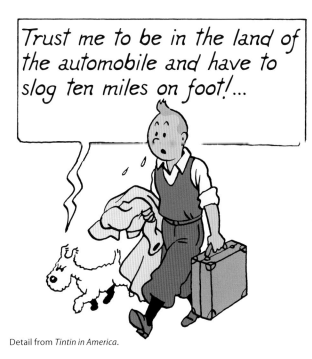

Detail from *Tintin in America*.

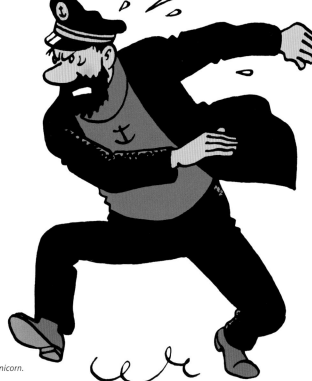

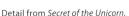

Detail from *Secret of the Unicorn*.

# Captain
# HADDOCK

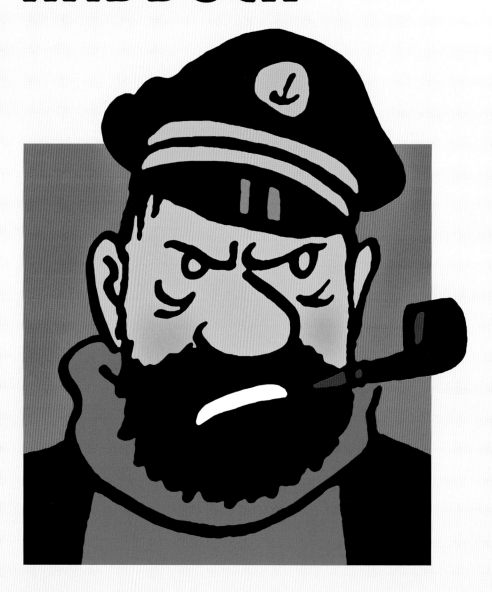

# Captain of aristocratic descent, a dipsomaniac, choleric but with a heart of gold.

The first appearance of Captain Haddock.
Frame from *The Crab with the Golden Claws*.

**D**espite or possibly because of his weakness for the bottle and explosive temper with its attendant repertoire of expletives, Captain Haddock is the most popular character in *The Adventures of Tintin*, opinion polls consistently show.

Even Tintin, without whom the adventures are impossible, is eclipsed. In recent surveys, 34 per cent of those questioned declared Tintin to be their favourite character but 37 per cent chose Captain Haddock. Snowy, meanwhile, trailed in third position with 13 per cent.

It is a remarkable success story, for when readers first came across Captain Haddock in *The Crab with the Golden Claws* (1941), he was a miserable whisky-sodden wretch who could do little but blubber about his mother. He then infuriates his newly acquired audience by almost putting an end to the redoubtable reporter first by burning the oars of their lifeboat to keep warm and then cracking him over the head with a bottle as Tintin is piloting an aircraft, causing it to crash in the desert.

Frame from *The Crab with the Golden Claws*.

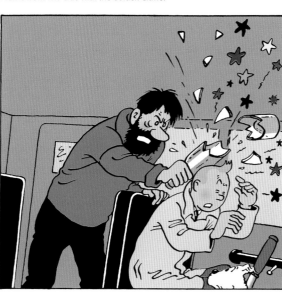

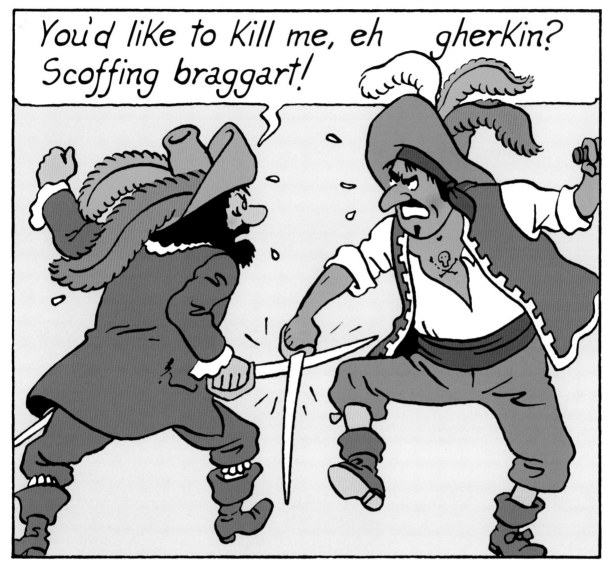

Frame from *The Secret of the Unicorn*.

From such an inauspicious beginning he becomes Tintin's closest friend, ready to lay down his life for him in *Tintin in Tibet*, to the detriment of Snowy whose role is reduced to third fiddle from second and whose conversational skills – unusual in a dog – are correspondingly curtailed.

Haddock's appeal is that his fallibility is remarkably human and endearing. Readers can identify with him, as Hergé himself did. For while Tintin represented the Boy Scout in Hergé – the resourcefulness, courage, honesty and integrity – all qualities admired and aspired to by the author, he too had his weaknesses and Haddock could mirror some of them. By 1940, Tintin needed such a companion; Snowy was no longer sufficient. Moreover, if the adventures needed to break away and escape from current affairs with the onset of war, then another principal character was needed for additional scope in what would become detective stories, scientific expeditions and treasure hunts.

## HADDOCK, AN ENGAGING
## AND ROMANTIC CHARACTER

Unlike Tintin, who has neither parents nor ancestors, Haddock has a distinguished pedigree traced back to his illustrious ancestor Sir Francis Haddock. This lineage makes him more real, more human. Captain Haddock becomes a truly romantic character with virtues and faults, as well as a family history, while Tintin remains a myth with numerous qualities but no background.

Reading the adventure of the knight-mariner, one understands better the often fiery, impetuous character of the Captain and the extent to which he resembles his proud forbear. Sir Francis, it should be noted, is as proficient with expletives as with his cutlass. Locked in combat on the quarter-deck of the Unicorn, he assails his pirate adversary with steel and insults, calling him a "pockmark," "gherkin" and "scoffing braggart!"

Haddock's weaknesses could make him unreliable, especially in his first few adventures, but he was warm-hearted and very forgivable. There was a parallel with Hergé, whose life was becoming more rather than less complicated as his reputation constantly grew. During the 1950s he himself could prove to be unreliable, disappearing without explanation from home and his work at *Tintin* magazine, letting down his first wife Germaine and his readers, as he went through a succession of personal crises, verging on breakdown.

By the time of *The Castafiore Emerald* (1963) Haddock in his wheelchair being fussed over to his irritation by Bianca Castafiore was Hergé at his country house in Brabant being mollycoddled by Germaine. By now separated from his first wife, Hergé could laugh at himself.

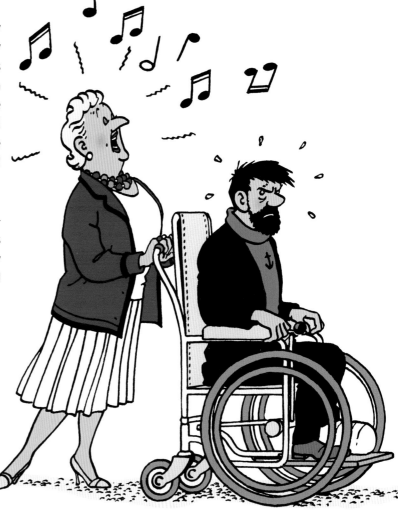

Detail from *The Castafiore Emerald*.

## A LITTLE OF HERGÉ … AND A TOUCH OF JACOBS

While Hergé admitted that there was a good deal of himself in Haddock, he also acknowledged that there was a measure of his colleague Edgar Pierre Jacobs who joined him later in the 1940s to assist with the adaptation of the books into colour, and then worked on with him for a while before moving on to create his own successful Blake and Mortimer series. A one-time opera singer, he was a noted bon viveur and raconteur. "Captain Haddock," Hergé conceded, "in part he's my friend Jacobs, who like him is gruff, capable of expansive gestures and prone occasionally to minor mishaps".

As Hergé was mulling over the introduction of a new character, a sea captain, he asked Germaine what she had cooked for dinner and she told him "aiglefin". She paused for a moment and added, "it's a sad English fish – haddock." Hey presto, he had the name for his new character.

## WHAT A STORY!

Little did Hergé realise when he created his character that there was a family in the south-east of England called Haddock with a distinguished naval pedigree, providing a succession of captains and admirals in the 17th and 18th centuries, coinciding exactly with his creation of Captain Haddock's ancestor Sir Francis Haddock in *The Secret of the Unicorn*, or that a certain H.J. Haddock was listed as Master of the Liverpool-registered White Star liner *Olympic* in 1913. Such juicy coincidental morsels confirming the authenticity of his choice emerged years later – to Hergé's delight.

Detail from *The Seven Crystal Balls*.

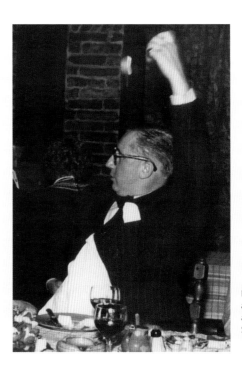

Edgar Pierre Jacobs at the annual *Tintin* magazine dinner at L'Auberge du Chevalier, September 1953.

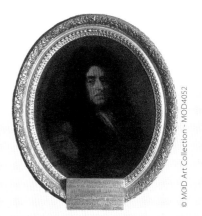

Sir Richard Haddock (1629–1715)
by John Closterman, oil on canvas.
United Kingdom Ministry of Defence
Art collection.

Among the Haddocks of Leigh-on-Sea, in Essex, was an Admiral Sir Richard Haddock (1629–1715) who would have been a direct contemporary of Hergé's Sir Francis Haddock, Captain Haddock's flamboyant ancestor. The future admiral commanded the *Royal James*, flagship of the Earl of Sandwich, at the battle of Sole Bay. The vessel went up in flames but Sir Richard was rescued and brought before King Charles II. To show his appreciation of Haddock's courage, the king is said to have doffed his satin hat and placed it on the head of Sir Richard – a truly Hergéan gesture, reminiscent of his account of the origin of the Syldavian national motto in *King Ottokar's Sceptre*. Sir Richard returned to sea as commander of another ship, the *Royal Charles*, before becoming a naval administrator. He was knighted in 1675 and promoted to Admiral in 1690.

Haddock rhymes with Craddock and when Hergé was developing his new nautical character he clearly recalled a popular film musical of 1933, *Captain Craddock*, for in the original French version of *The Crab with the Golden Claws* (page 42) an inebriated Captain Haddock meanders down the quayside singing a line from it.

Frame from *King Ottokar's Sceptre*.

## HADDOCK, THE OPPOSITE OF TINTIN

By the autumn of 1940 when Hergé was working on the adventure into which he was about to introduce Captain Haddock, he had more than 10 years of experience creating adventures for his resourceful reporter. While the secret of Tintin's success may have been the simplicity of his features and the ease with which young readers could identify with him, the new characters Hergé was creating brought fresh and different possibilities to the adventures. In the case of Captain Haddock, he devised a character who was the exact opposite of Tintin – weak where Tintin was resolute, unreliable instead of dependable, choleric rather than calm, and so on.

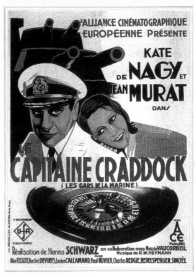

Poster of *Le Capitaine Craddock*, 1933.

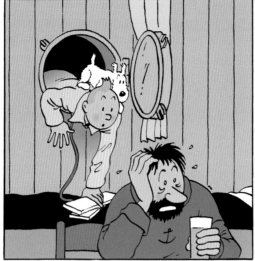

While Tintin's expressions reveal a minimum, Haddock's face mirrors all his inner turmoil, his anger and his joy. Hergé uses an entirely different style of drawing to portray a much more complex character. The one was the ideal foil to the other and with 8 adventures behind Tintin and 16 to go, the time was ripe for such a development.

Talking years later to Numa Sadoul, Hergé said that no more than with the Milanese nightingale, Bianca Castafiore, did he imagine that Haddock would take on a front-line role: "He really dragged me into it, almost by force. He imposed himself! To begin with he wasn't likeable at all. He was a drunk, a slave of his vice: a real wreck. When he sows panic among the ranks of Arabs fleeing his furious temper [page 38], he is not heroic at all, just drunk …"

And so he was at our, and Tintin's, first encounter with him on pages 14–15 of *The Crab with the Golden Claws*. One mention by Tintin of his reputation and his mother and the Captain dissolves into a flood of tears. It is an unedifying spectacle and it is indeed hard to believe that Hergé at this point saw any great future for the pathetic character he had just created.

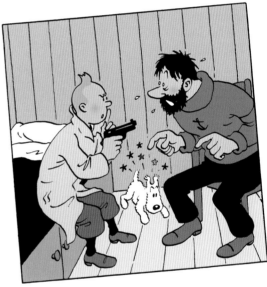

Frames from *The Crab with the Golden Claws*.
The first appearance of Captain Haddock.

## A MASTER OF THE EXPLETIVE

It is that opening tirade of insults that the drunken Haddock hurls at the Arab raiders that establishes his place, and entertainment value, in the adventures. He has secreted several bottles from Lieutenant Delcourt's headquarters only to see them shattered by the Berber marksmen. His fury is depicted with graphic realism and he opens his account of expletives with

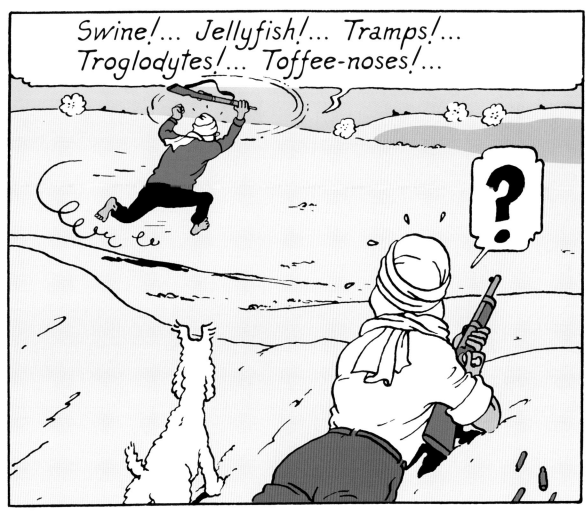

Frame from *The Crab with the Golden Claws*.

a tally of 20 terms of abuse as an opening blast! It amounts to roughly a tenth of his total repertoire, which Tintinologists have counted at over 200 insults. It seems to be more than the desert marauders can take and they exit, stage right, pretty hastily. Though it is, in fact, the sight of Lieutenant Delcourt's approaching mounted patrol that prompts their retreat, not Captain Haddock's inventive vocabulary.

Hergé clearly derived much pleasure from devising and deploying such a barrage of irrelevant abuse. The idea stemmed from an argument he witnessed between a shopkeeper and customer which ended abruptly when, after an exchange of conventional insults, "You Four Powers Pact!" came out – an unexpected reference to the treaty signed in July 1933 between Britain, France, Germany and Italy. Its total irrelevance proved completely disarming. The more obscure and obtuse the term, Hergé realised, the more effective.

He would delve in dictionaries, particularly his *Larousse*, picking unusual words for use. Favoured areas were – appropriately for Haddock – nautical, scientific for obscurity, ethnographic and zoological for colour. He kept the *Larousse* on a filing cabinet and would open it and choose outlandish words. Insults could be embellished by unlikely combinations of words and alliteration.

Haddock's best-known and stock expletives in French are "Mille Sabords!" (exclaimed 166 times, according to the calculations of Tintinologists) in multiple forms, cleverly transformed by his English translators into "Billions of blue blistering barnacles!" and "Tonnerre de Brest!" (used on 144 occasions) which becomes "Thundering typhoons!" In extreme cases he can even combine the two, as in "Billions of bilious blue blistering barnacles in a thundering typhoon!" Elevating swear words to an art form was quite an achievement for a strip cartoon that was primarily intended for children.

## AN AQUAPHOBE, WHEN IT COMES TO DRINK!

The swearing suits the Captain's nautical background, his hot temper and fondness for the bottle. While he detests drinking water, he is partial to dry alcohol. Whisky, however, is Haddock's great love until Professor Calculus spoils the Captain's palate by slipping him some of his anti-alcohol pills (*Tintin and the Picaros*).

In one of the rediscovered but unused pages for *Tintin and Alph-Art*, there is a rough sketch of Haddock, palette and brush in hand before an easel and canvas. Below, more alarmingly, is an image of his hairless and beardless head covered in large spots or blotches. Hergé has noted alongside: "The Captain has become neurasthenic (as he can no longer drink whisky). He has begun to paint." Happily for Haddock, the Professor invents a product to restore the Captain's taste for whisky. It is whisky that Captain Haddock – despite all regulations to the contrary – smuggles aboard the Moon rocket concealed in a hollowed out 'Guide to Astronomy' and which subsequently, to his consternation and bewilderment, floats out of his glass in a golden ball under conditions of weightlessness. Mention of the word "whisky" is enough to revive the unconscious Haddock after he is brought out of the Moon rocket on its return to Earth.

Detail from *Tintin and Alph-Art*; Haddock dabbles in painting.

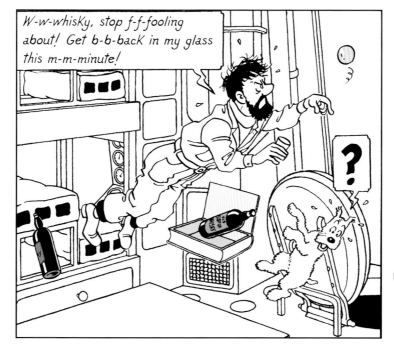

Frame from *Explorers on the Moon*.

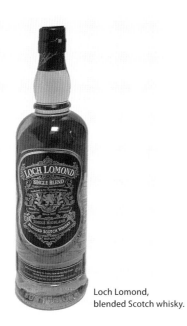

Loch Lomond,
blended Scotch whisky.

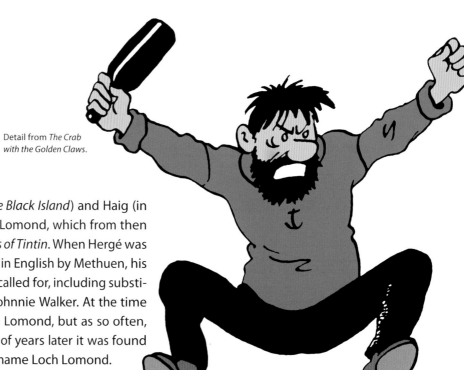

Detail from *The Crab
with the Golden Claws*.

The very real brands of Johnnie Walker (in *The Black Island*) and Haig (in *The Red Sea Sharks*) gave way in 1966 to Loch Lomond, which from then on became the house whisky of *The Adventures of Tintin*. When Hergé was asked to revise *The Black Island* for publication in English by Methuen, his London publisher, a number of changes were called for, including substituting a fictitious brand for the well-known Johnnie Walker. At the time there was no record of any brand called Loch Lomond, but as so often, reality would catch up with Hergé. A number of years later it was found that there was indeed a blend sold under the name Loch Lomond.

As to be expected of a sailor, Captain Haddock also enjoyed quality rum, especially the 17th century distillation recovered intact in quantities from the bottom of the Caribbean in *Red Rackham's Treasure*. It is rum too, which lubricates Captain Haddock's emotional account of his ancestor Sir Francis Haddock's encounter with the pirate Red Rackham in *The Secret of the Unicorn*. "Ration my rum!" is a favourite expression of Sir Francis, so much so that the parrots on the Caribbean island to which he escaped have passed it on from generation to generation and still squawk it.

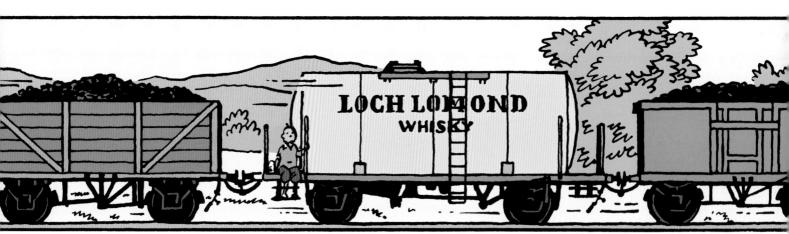

Frame from *The Black Island*.

## A HEROIC FRIEND

Despite all his vices, weaknesses and faults, Captain Haddock is an essentially good, even heroic figure when it comes to the ultimate test. This, readers find in *Tintin in Tibet*, the adventure that became the most personal and important for Hergé.

Roped to Tintin, climbing a sheer crag in the Himalayas, a piece of rock breaks away and Haddock loses his footing. He is left hanging perilously in mid-air. "Can you hang on up there?" he calls to Tintin. "For as long as possible … But I can feel myself getting weaker, and paralysed with cold," Tintin replies. "Which means we both fall! That's no good, young fellow. You, at least, can save yourself. You must cut the rope: it's the only answer!" directs the Captain. Tintin refuses: "Never, you hear me? … I'll never do that!" To which Haddock responds: "All right. I'll do it myself … Get my knife … and that's it … Cast off moorings!" But he has difficulties opening the blade of his clasp knife with his fingers numbed by cold, and clumsily drops it down the mountain; only for Tharkey, their Sherpa, to return and rescue the two seemingly doomed climbers.

The fact that Haddock does not hesitate to make the ultimate sacrifice to save his friend, along with other examples of his loyalty to his companions, whether Tintin or Professor Calculus, underlines his fundamental place, value and popularity in *The Adventures of Tintin*. "Blistering barnacles!"

And if Tintin were to be saved from his final statuesque fate in *Tintin and Alph-Art*, surely Captain Haddock would be the rescuer? Locked in a dungeon, Tintin's last words are to Snowy whom he hears outside the ventilation grille: "Snowy! … Wait, I'll give you a message to give to the Captain … to the Captain, understand?" After several attempts, Snowy manages to seize the message and run off …

What follows, like life itself, we will never know. ▮

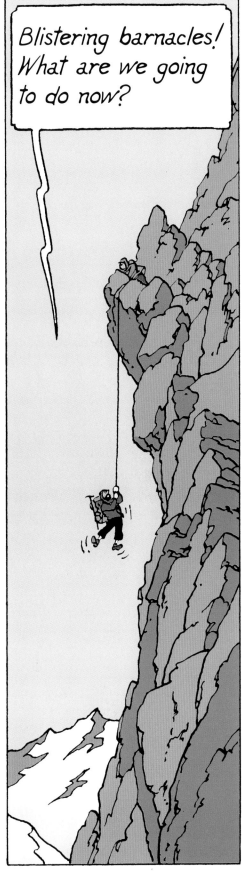

Frame from
*Tintin in Tibet*.

# Professor
# CALCULUS

# A highly eccentric scientist; romantic, visionary, absent-minded ... and a little hard of hearing.

The most extraordinary fact about Professor Cuthbert Calculus is that Tintin waited the best part of 15 years to meet him and then, initially at least, neither the reporter nor Captain Haddock wanted anything to do with him.

The first 11 Tintin adventures came and went in a cavalcade of excitement that included a selection of eccentric professors. Then, in 1944, came *Red Rackham's Treasure* with Professor Calculus. The absurdly deaf, absent-minded inventor of genius was here to stay, if only because his money allowed Captain Haddock to purchase Marlinspike Hall, his ancestral home, at the end of the adventure.

Greatly to the benefit of the series, Professor Calculus was to play a lesser or greater role (notably in the Moon adventures and *The Calculus Affair*) for the remaining 12 adventures. Although his deafness and obstinacy can drive Captain Haddock to distraction, he is an immensely endearing character, not least because of his very human susceptibility to the fair sex.

The first appearance of Professor Calculus.
Frame from *Red Rackham's Treasure*.

Frames from
*Red Rackham's Treasure*.

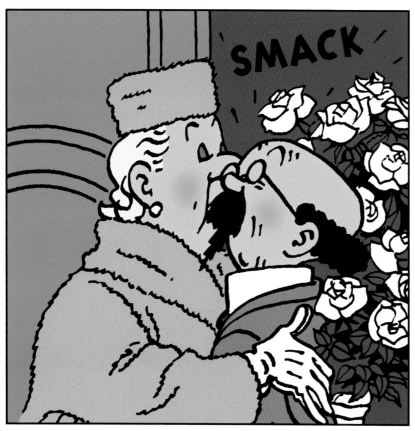

Frame and detail from *The Castafiore Emerald*.

## CALCULUS THE ROMANTIC

He is a romantic in the broadest sense, whether in such grand designs as taking a manned rocket to the Moon and back or, as a horticulturalist, in breeding a rose he names Bianca after the object of his affection, the stately Castafiore. Her kiss of gratitude prompts a delighted blush that seems to burn through the page's paper. Calculus is no butterfly and the Milanese nightingale retains his affection throughout. Distraught at news of her arrest in *Tintin and the Picaros*, he arrives at the guerrilla camp, but cannot help being seduced by the unlikely charms – curlers, spectacles and false teeth – of Alcazar's fearsome spouse Peggy. When it comes to women, Calculus is an old-fashioned romantic, something of a Don Quixote in search of his Dulcinea. In a series of adventures where there is little time for romance, this provides welcome and delightful relief.

## DEAFNESS

Calculus is primarily a comic figure on account of the deafness that leads to a constant stream of misunderstandings. Like many people whose hearing is in decline, the Professor is himself reluctant to admit it, acknowledging only that he may be hard of hearing. Yet when the handicap could impair vital work or, for instance, his own participation in the Moon project, he takes to using an ear trumpet with mixed results, and eventually a hearing aid for the mission itself with a very marked benefit. After its proven success, one

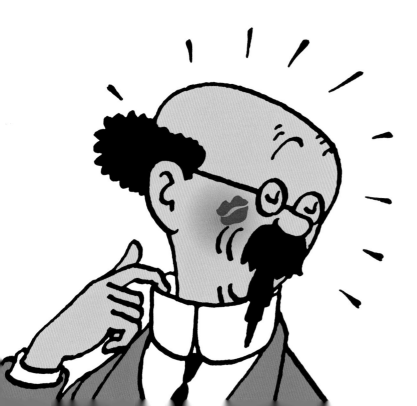

Don't you agree?... But I've invented a machine for underwater exploration, and it's shark-proof. If you'll come to my house with me, I'll show it to you.

I'm very sorry but...

Why of course. Certainly these gentlemen may come too.

It's no good. There's no time! NO TIME!

Good, that's settled. We'll go at once.

Frames from *Red Rackham's Treasure*.

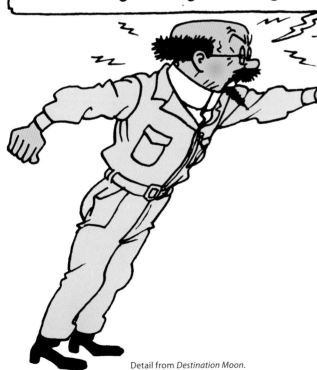

Begone, you worm! Out of my sight! I'm acting the goat, d'you hear?

Detail from *Destination Moon*.

wonders why following his return from the Moon he dispenses with the device. The answer is probably vanity and, as far as Hergé was concerned, a reduction in his comic potential.

Hergé had clearly observed the deaf for his portrayal. Calculus mishears words or partly catches them, causing the misunderstandings and his splendid non-consequential answers. Sometimes, however, he unexpectedly grasps a word or expression perfectly – the "acting the goat!" (page 39, *Destination Moon*) that so infuriates him, as can be the case with the deaf. Yet despite its accuracy, Hergé's rendering of the problem is never cruel.

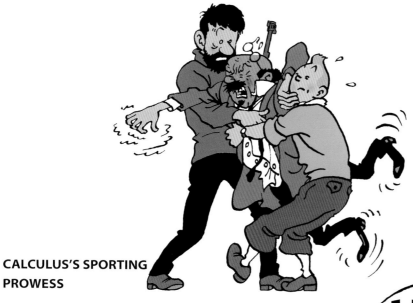

Two details from *Flight 714 to Sydney*.

## CALCULUS'S SPORTING PROWESS

In stark contrast to Calculus's infirmity is his self-confessed athletic prowess, which he takes great pride in detailing in the airport scene of *Flight 714 to Sydney*. When the billionaire aircraft manufacturer Laszlo Carreidas asks hopefully whether he plays the game "Battleships", the Professor mishears: "Battledore? I used to be very good … And not only battledore [a bat used in the game of shuttlecock]. I've been an all-round sportsman in my time … tennis, swimming, rugger, soccer, fencing, skating … I did them all in my young days. Not forgetting the ring, too: wrestling, boxing, and even savate or French boxing … Stars above! They make me laugh nowadays with their judo and karate. Savate! That was real fighting!"

Already in his debut adventure, *Red Rackham's Treasure*, he rows the dinghy carrying Haddock and the buoy to the spot where Tintin has let off the smoke flare. "No, but I was a great sportsman in my youth … And that accounts for the athletic figure I still have …" he relates to an otherwise preoccupied Haddock. The Captain clearly knows of the Professor's Olympian aspirations when, in a display of impatience with Calculus and his pendulum, he snatches the device and hurls it away: "Now your infernal pendulum's gone west, you Olympic athlete, you!" Note how, his strength fuelled by fury, he lifts with such apparent ease the massively square-shouldered security guard in *Destination Moon* and hangs him up by his collar on the hat and coat rail. Similarly, in another fit of rage, Tintin and Haddock have to save Carreidas from a savage mauling by Calculus in *Flight 714 to Sydney*.

Movements in French boxing, in which feet are used as well as fists, illustrated in the 20th century *Larousse*, in six volumes, Paris 1928.

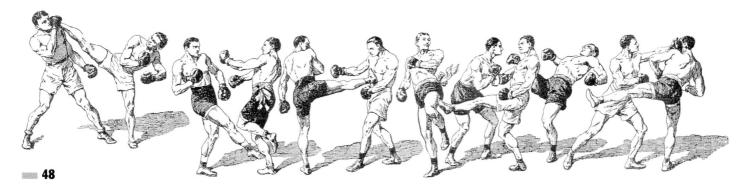

Auguste Piccard in May 1952.

Frame from *Tintin in Tibet*.

Auguste Piccard inspecting
a porthole of his bathyscaphe.

Frame from *Red Rackham's Treasure*.

## PICCARD AS MODEL

For Professor Cuthbert Calculus (Tryphon Tournesol in the French original – Tournesol
translates as sunflower, while Tryphon was the unusual first name of a carpenter
Hergé had come across) Hergé had a very particular model in mind: Auguste Piccard,
a remarkable Swiss scientist who held a professorship at the University of Brussels.
Piccard stood out on account of his height (almost six foot six inches – 1.96 metres),
which he did not share with Professor Calculus, and his somewhat eccentric old-
fashioned style of dressing – accentuated by an unusually long neck – that was almost
identical to Hergé's creation.

Like Professor Alembick in *King Ottokar's Sceptre*, Piccard too had a twin brother who
was also a distinguished scientist, but in America. Auguste Piccard's chief distinction
was before the Second World War to have soared higher into the stratosphere than
anyone previously, and afterwards in his bathyscaphe to have plunged deeper into
the ocean. Born in Basle in 1884, he became professor of physics at the University of
Brussels in 1922, a post he held until 1954. In 1931–32, he made record ascents to 55,000
feet in a balloon of his own design, resulting in important discoveries concerning such
stratospheric phenomena as cosmic rays. Contemporary photographs show Piccard
and a colleague wearing wicker helmets for the record-breaking ascent, as well as
a wing-collar and tie! His picture featured regularly in *Le Vingtième Siècle* and other
Brussels newspapers that Hergé would see daily. Meanwhile, his twin brother Jean,
who was professor of aeronautical engineering at the University of Minnesota, made
a remarkable balloon ascent together with his wife in Detroit in 1934. Furthermore,
demonstrating that ballooning and an appetite for heights could be in the genes,
Auguste's grandson Bertrand Piccard became, in 1999, together with the Briton Brian
Jones, the first to circumnavigate the world non-stop in a balloon. Hergé would have
been delighted at such an achievement in the very year that Tintin marked his
70th anniversary.

Frame from *The Calculus Affair*.

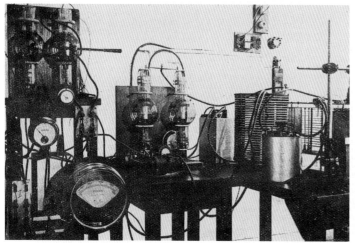

Photograph of a laboratory in Hergé's archive.

Frame from *The Castafiore Emerald*.

## CALCULUS THE INVENTOR

Auguste Piccard's post-war development of bathy-scaphes and deep-sea submarines make it strangely appropriate that Professor Calculus's entry into *The Adventures of Tintin* comes as a result of his invention of a one-man submarine, which he proposes to Tintin and Haddock as an aid to their search for *Red Rackham's Treasure*. Published in book form in 1944, the adventure thus predates Piccard's submarine achievements. Similarly Calculus's most outstanding feat, landing the first man on the Moon in 1953, anticipated the American achievement by 16 years! Calculus's rocket is nuclear-powered – considered at the time a viable option – and among the findings credited to Piccard is Uranium 235. Other inventions of his, apart from the bathyscaphe, include the principal of the pressurised capsule and ultra precise scales, seismograph and galvanometer. He shared Calculus's hunger for experiment and thirst for invention, though Hergé's Professor included the practical and banal among his list of inventions: a new device for putting bubbles into soda water, a clothes-brushing machine, a collapsible wall-bed, motorised roller-skates and colour television. In *The Calculus Affair* he makes a potentially dangerous break-through in the use of ultrasonic sound.

Professor Calculus also has some ability as a chemist – a discipline not shared with Piccard – devising an antidote to Dr Müller's Formula Fourteen in *Land of Black Gold*, though causing extensive damage to Marlinspike in the process, and subsequently, in the final adventures, working on a pill which makes alcohol distasteful (*Tintin and the Picaros*) and then palatable again (*Tintin and Alph-Art*).

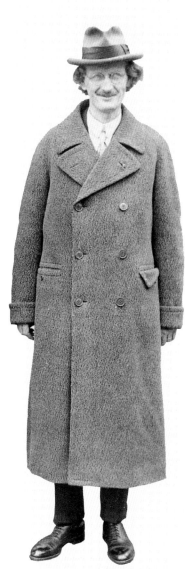

## A MOST DISTINCTIVE APPEARANCE

Like Piccard, a highly conservative, old-fashioned appearance – both men would insist on wearing a tie and had a preference for stiff collars – belied a position at the cutting edge of science.

While Piccard had a moustache, an endless neck and spectacles, Hergé gave Calculus a goatee as well. They dressed in a similar fashion – white shirt, collar and narrow dark tie, black trousers, green jacket and overcoat, hat and indispensable umbrella (which even goes on the Moon mission). Once, in *The Seven Crystal Balls*, we find Calculus wearing a black jacket, which looks particularly smart and well cut. He would sometimes add a buff-coloured waistcoat to his ensemble and, if gardening, a broad-rimmed panama hat. Piccard would often wear a beret and cape and go out with a stick. On the deck of the Sirius in *Red Rackham's Treasure* and again towards the end of *The Calculus Affair*, Calculus sports such a beret.

We do not know about Piccard's nightwear, but Calculus has a preference for nightshirts, as we know from *The Seven Crystal Balls* (plain white) and *Destination Moon* (lilac), though he changes to cream (and later light green) pyjamas in *Tintin and the Picaros*, over which he wears a smart dressing gown. He is also shown in an incongruous yellow towelling bathrobe that, absorbed in a book, he forgets to take off in the bath.

Although an old-fashioned dresser, Calculus has an unexpected taste for jewellery that leads to trouble in *The Seven Crystal Balls* when he finds and picks up the gold bracelet of Rascar Capac: "Really splendid … and how well it goes with my coat!" Calculus does not make it back to the house and we next find him in Peru in the sequel adventure, *Prisoners of the Sun*, where he is held captive by the Incas for having committed the sacrilege

Auguste Piccard dressed in a manner unmistakeably evocative of Professor Calculus. The outstanding physicist and inventor who inspired Professor Calculus died in 1962, aged 78.

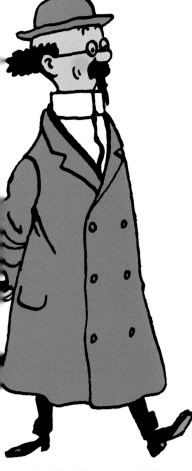

Detail from *The Seven Crystal Balls*.

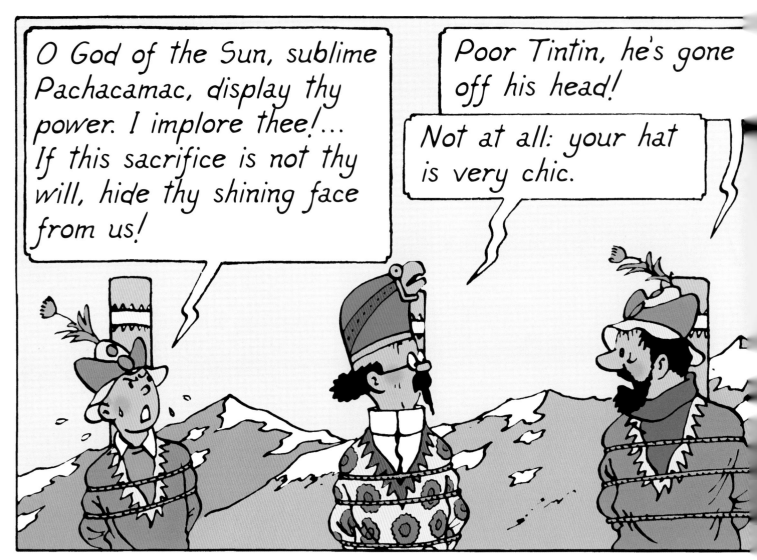

Frame from *Prisoners of the Sun*.

of putting on the sacred bracelet. He is led out by a choir of chanting virgins to join Tintin and Haddock on the sacrificial pyre. Needless to say he is still wearing his starched collar and thin black tie, but on top he has a colourful, patterned sacrificial robe and an extravagant mitre-like hat with an eagle's head. On the final page his commitment to hats is demonstrated by a bright red Inca wool cap with ear flaps, an incongruous accessory for the long journey home.

## OBSTINACY AND MISUNDERSTANDING

Professor Calculus has all the self-assurance and stubbornness, as well as some of the petulance, of the scientist determined to see his ideas through. This persistence is evident at his first meeting with Tintin and Haddock in *Red Rackham's Treasure* when he will not take no for an answer, even when to counter his deafness Haddock writes it on the wall. He had already dragged Tintin and Haddock against their will to his

# WE ARE NOT INTERESTED IN YOUR MACHINE!

workshop and showed them the shark submarine prototype before it collapsed under his weight: "No, Professor Calculus, I said your machine won't do for us!" To which he replies astonishingly: "Oh, good! … Well gentlemen, that's agreed. I'll make another smaller one …"

There is a similar misunderstanding in *Destination Moon* when, over a bottle of port, Calculus invites Tintin and Haddock to join him on the mission to the Moon. "Me? … On the Moon! … With you? … Blistering barnacles! Your brain's gone radioactive! On the Moon! You'd just push me around, like that, without a word! … I'll never set foot in your infernal rocket, d'you hear me? Thundering typhoons! … Never!" Without flinching the Professor responds: "Oh, thank you, Captain … thank you! … I knew I could count on you." The observant reader will have noticed that listening to Haddock's outburst, Calculus had in a Nelsonian touch picked up the Captain's pipe and held it to his ear instead of his hearing-trumpet.

Details from
*Red Rackham's Treasure.*

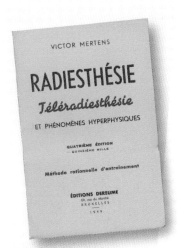

Radiesthésie Téléradiesthésie et phénomènes hyperphysiques, a book on dowsing published in Brussels in 1949 that Hergé acquired.

## DOWSING

Another interest of the Professor is dowsing or divining, for which he carries a pendulum and succeeds in irritating Captain Haddock on numerous occasions, but otherwise achieves very little. In *Red Rackham's Treasure* his pendulum is forever directing him westwards to no avail. When he is totally immersed in scientific projects such as the Moon rocket or the ultrasonic experiments of *The Calculus Affair*, this less serious side pursuit is forgotten, though it is taken up by the Thom(p)sons – again without success – in their hunt for the Professor in *Prisoners of the Sun*. The pendulum can be seen dangling out of Calculus's pocket in the hotel scene at the start of *Tintin in Tibet* and he puts it to use once more in *The Castafiore Emerald* and *Flight 714 to Sydney*.

## CALCULUS ASSERTS HIMSELF

Hergé's introduction of Calculus in *Red Rackham's Treasure* achieved several objectives that strengthen the narrative so successfully that he could not dispense with him subsequently, even in adventures like *Tintin in Tibet* or *Tintin and Alph-Art*, as we know it, when he just has a minor, walk-on role, or *Land of Black Gold* where he only participates by post at the end.

Firstly, he fulfilled Hergé's desire for an eccentric, absent-minded professor type. The earlier adventures had been punctuated by such professors. The mentally unstable Doctor Sarcophagus in *Cigars of the Pharaoh*, the anonymous and wholly distrait professor in *The Broken Ear* (page 6), the chain-smoking Sigillographer, Professor Hector Alembick (a play on the well-known Belgian beer, Lambic, while in English an alembic is an apparatus formerly used in distilling) in *King Ottokar's Sceptre*, Professor Phostle and a gallery of fellow academics in *The Shooting Star*. Professor Fang Hsi-ying in *The Blue Lotus*, "the world authority on madness," is an exception for being portrayed as a wholly serious character without eccentricity.

Detail from *The Shooting Star*.

Post-Calculus and apart from him, Hergé manages furthermore to fill a hospital ward with professors, stricken with a mystery ailment, in *The Seven Crystal Balls* and *Prisoners of the Sun*.

Secondly, the inclusion of Professor Calculus allowed Hergé obvious scope to tackle scientific subjects, best exemplified in the Moon adventures and *The Calculus Affair*. Even at this stage, *The Adventures of Tintin* retained some of the pedagogic aims of the early *Petit Vingtième* days, if only on account of the primarily youthful readership. *Tintin* magazine, in which the post-war adventures first appeared, strove to instruct as well as to entertain.

Thirdly, Professor Calculus injects an added, different level of humour through his constant mishearing and misunderstandings, quite different to the slapstick comedy provided by the Thom(p)sons or the irascible buffoonery of Captain Haddock. For this reason and for continuity, once established, Hergé could not drop him. His permanence is demonstrated by the fact that after he helps Haddock buy Marlinspike Hall with money from the patent for his submarine, he moves in with the Captain and they are later joined by Tintin. The three are permanent fixtures, of Marlinspike and of the subsequent adventures.

In the last completed adventure, *Tintin and the Picaros*, it is Professor Calculus who has the final word, as he had in his first adventure 32 years earlier. "Blistering barnacles, I shan't be sorry to be back home at Marlinspike …" says Captain Haddock. "Me too, Captain …" replies Tintin as they fly over the shanty towns of San Theodoros. "Me too, but with a little mustard if you please," Calculus adds, winding up proceedings with an ultimate non sequitur. ∎

Detail from *The Calculus Affair*.

Some other scientists to be found in *The Adventures of Tintin*.

# THOMSON and
# THOMPSON

# Incompetent, clumsy buffoons despite their best intentions; they rank as kings of comedy slapstick.

The first appearance of the Thom(p)sons.
Frame from *Cigars of the Pharaoh*.

**T**homson and Thompson – or the Thom(p)sons for ease of reference – are veteran, enduring figures in *The Adventures of Tintin* appearing to a lesser or greater extent in 20 out of the altogether 24 books. Excluding of course Tintin and Snowy, no other characters can boast so many appearances, not even Captain Haddock who, arriving later, was to star in 16 adventures.

It would be a distinguished record if only they were not such professional failures as detectives. Chronically clumsy, they are constantly slipping up or tripping over, both physically and verbally. They are, in modern terms largely unrecognised at the time, both dyspraxic and dyslexic.

They are, moreover, exceedingly naive, hopelessly narrow-minded, and obnoxiously full of self-importance. The two are, in short, pompous, credulous fools with a penchant for fancy dress. Though hardly endearing, they bring hilarity to the adventures. The bumbling detectives provide the necessary counterpoint to the rough and tumble, the excitement of the narrative, allowing a necessary relaxation of tension.

Frames from *Tintin and the Picaros*.

Detail from *Destination Moon*.

## OCCASIONALLY INSPIRED, RARELY COURAGEOUS

The two detectives have their inspired moments, even if dictated by duty. In *Cigars of the Pharaoh*, their first adventure, in the unlikely guise of Arab ladies, they organise Tintin's survival of execution by firing squad … in order to arrest him "as a drug smuggler and gun-runner"! Arriving in India, they show surprising inventiveness in saving the life of Snowy – about to be sacrificed on the altar of Siva – so as to use him to track down his master. "How wrong I was. They're really pretty good chaps!" Snowy declares appreciatively.

Their character is often questionable, combining stupidity, arrogance and cowardice, but finally in *Tintin and the Picaros* they redeem themselves heroically, refusing first to be cowed by the vitriol of the military tribunal, and then showing unusual steadfastness and sangfroid – admittedly bolstered by alcohol – before the firing squad.

Despite being detectives and enforcers of the law, they are generally far from courageous. They have a particular fear of the supernatural. In the rooms and corridors of the rocket research centre in Syldavia in *Destination Moon*, they take fright after mistaking each other's skeletal x-ray image for a ghost. Their next funk comes as they jump onto a chair terrified after encountering white mice that have escaped from Captain Haddock's space suit. Courage does not course through their veins.

## THE ACTUAL MODELS

As often with Hergé he drew on more than one source for his inspiration. The most immediate came from home. His father, Alexis Remi, had an identical twin brother, Léon. They both sported moustaches, dressed in the same fashion and shared at least one catchphrase with the detectives – the French "je dirais même plus!" (freely translated in the English editions as "To be precise!") that is used in one form or other more than 60 times during the course of the adventures.

On Sunday mornings the Remi twins would don their bowler hats, pick up either their walking canes or, depending on the weather, umbrellas and venture forth for their weekly constitutional. This ritual left an image firmly imprinted on the young Georges's mind. While later acknowledging this, Hergé maintained that he was not consciously thinking of them when he created the Thom(p)sons. Yet subconsciously the recollection was clearly there. To this day, as a tribute to the Remi brothers and the Thom(p)sons, a pair of bowler hats and two sticks hang expectantly on their pegs in the lobby of the Studios Hergé in Avenue Louise in Brussels.

Hergé embarked on *The Adventures of Tintin* during the heyday of that bowler-hatted, cane-flourishing, anti-hero Charlie Chaplin. Born in London in 1889, worldwide fame came with the silent cinema and his portrayal of a down-trodden tramp-like character with smudge moustache, bowler hat and cane. In *Modern Times* (1936), he shows man's predicament in the machine-age, a subject Hergé had already explored in *Tintin in America* (1932). Hergé was a great fan of Chaplin and keenly aware of contemporary cinema and some of its techniques which he tried to apply to the strip cartoon.

Of course there were two other contemporary comedy film stars with bowler hats: Laurel and Hardy. Their childish contrition could be echoed by the Thom(p)sons. There is too the cover of *Le Miroir* of March 1919 in Hergé's archive which shows two bowler-hatted, moustached detectives with a suspect. Their resemblance to the Thom(p)sons is staggering.

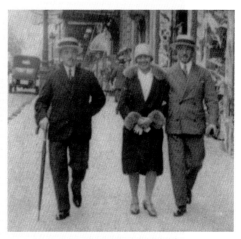

The inseparable twins Alexis and Léon Remi, in 1928.

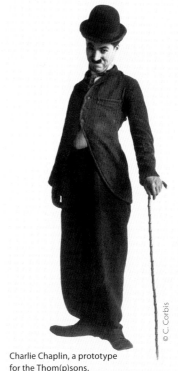

Charlie Chaplin, a prototype for the Thom(p)sons.

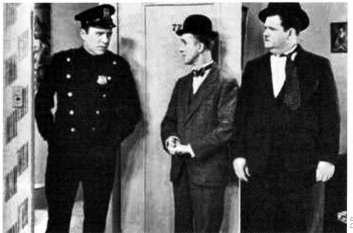

*Unaccustomed As We Are* (1929), short film by Lewis R. Foster with Stan Laurel and Oliver Hardy.

## SPOT THE DIFFERENCES

One fundamental difference between the Thom(p)sons and Alexis and Léon Remi is the fact that the detectives are neither twins nor identical. They cannot be brothers either, for though similar their surnames are different – that 'p', as in 'psychology.' Moreover, their moustaches are significantly not trimmed in quite the same manner. Thompson has it clipped straighter, while Thomson allows a slight, distinctive twirl at the ends.

There is the wonderful moment in the last completed adventure, *Tintin and the Picaros*, where the public prosecutor accuses the pair of cultivating their moustaches in order "to appear as loyal supporters of General Tapioca and the noble ideology of Kûrvi-Tasch." Thompson protests furiously: "That's a lie! … We've been wearing moustaches since we were born!" Thomson adding: "To be precise: we're worn bearing them!"

## FIRST APPEARANCES

The Thom(p)sons' real debut comes in *Cigars of the Pharaoh* (1934) where in the first black and white French version they are identified mysteriously but unmemorably as agents 'X33 et X33 bis' (in English X33 and X33A), only later being named 'Dupond et Dupont' in French and Thomson and Thompson in English. However, when Hergé revised *Tintin in the Congo* (1931) for its 1946 colour edition, he defied the chronology of the Tintin books and inserted in its opening departure scene the Thom(p)sons on the railway platform in place of the two porters he had before. "It's apparently a young reporter who's leaving for Africa …" one says to the other. Their role in this early flawed adventure extends no further.

The Thom(p)sons' true introduction into the adventures in *Cigars of the Pharaoh* is full of menace. They are first seen peering through the deck doorway as Tintin enters his cabin on the M.S. Isis. They rap aggressively on the cabin door, enter and, striking identical poses, announce in chorus his arrest. It is an unfortunate start to a relationship that for several adventures is dogged by uncertainty with the Thom(p)sons spending more time mistakenly pursuing Tintin rather than the actual malefactors.

Detail from *Cigars of the Pharaoh*.

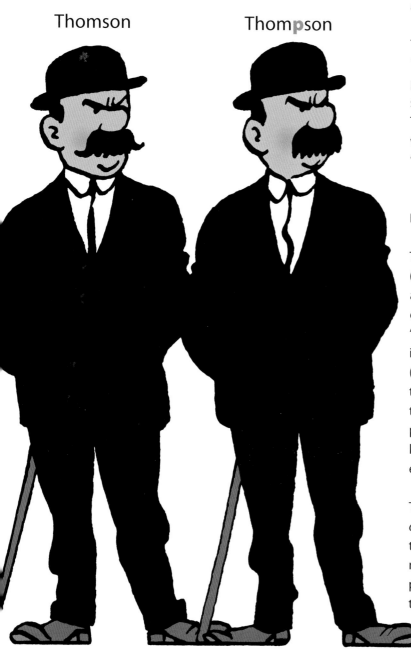

# Thomson　　Thom**p**son

## THE COMEDY OF THE SITUATION

The comic effect of the Thom(p)sons and their escapades is tailored according to the plot of each adventure in which they make their mark. Their professional status as detectives allows them to slip into the narrative quite naturally. The misunderstandings, blunders, their spectacular and repeated tumbles and falls, the absurd fancy dressing, all offer relief at the right moment at the expense of the ridiculous pair of sleuths.

So in *Prisoners of the Sun*, having lost Tintin and Haddock in South America, the Thom(p)sons reappear later in half a dozen mostly single-frame cameos defying time and distance by popping up in greatly contrasting geographic locations in a pendulum-led search. While comic, it also has a surreal quality, notably the images of the suited, bowler-hatted figures under the blazing desert sun or amid the frozen Antarctic expanse, reminiscent of the painter Magritte.

They end up in the desert in *Land of Black Gold*, which by its conclusion has far-reaching capillary consequences for them. But they begin in great good humour motoring along and singing to a melody inspired by the popular *chansonnier* Charles Trenet until their car blows up and soon afterwards so does Thompson's lighter, fuelled by the same petrol they topped up with at the garage. They gain employment as mechanics with a vehicle recovery firm in an attempt to get to the bottom of the blight of explosions affecting motorists, but are soon sacked for incompetence.

Once in Arabia, they set out in a bright red jeep, Thompson as usual at the wheel. They fall victim to a series of real or imagined mirages but continue on their way, memorably driving round and round in a circle following their own tracks, an idea which occurred to Hergé after he saw a photograph in the *National Geographic* magazine of vehicle tracks imprinted in the desert sand. Somehow they find Tintin in a sandstorm and subsequently, dropping off at the wheel, they crash sacrilegiously into a mosque during prayers.

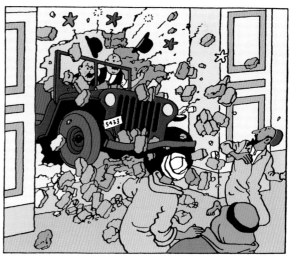

Details and frame from *Land of Black Gold*.

Frame from *Land of Black Gold*.

There is comedy too when they make the mistake of picking up what appears to be a tube of aspirin and take a tablet each to ease their headaches. The tube contains Formula Fourteen used by the villain Müller and the foreign power backing him to spike petrol supplies. The detectives begin burping bubbles and start growing hair and beards at a phenomenal rate and in varying colours. The affliction is liable to return at any time despite powders developed by Calculus as an antidote. Their disconcerting discovery does at least thwart plans to disrupt international oil production.

These two plain-clothed detectives also have a penchant for dressing-up. Their wish to blend in with the local population wherever they may be invariably causes them to stand out!

Details from *Cigars of the Pharaoh*.

Detail from *Destination Moon*.

Detail from *The Calculus Affair*.

Frame from *The Blue Lotus*.

Details from *Land of Black Gold*.

Detail from *The Black Island.*

## ACROBATICS AND TUMBLES GALORE

Hergé mastered the subtleties of staging the numerous acrobatics, spins and tumbles of the Thom(p)sons. The reader comes to anticipate them – if not the spectacular effects. It all started at the end of *Cigars of the Pharaoh* when Tintin borrows the Maharaja's racing car and they fail to hang on. It becomes a standard joke, along with their bowlers being blown off at every airport, and their unfailing propensity for getting soaked by falling into the sea. Additionally, their metal-heeled, hobnailed police boots guarantee that they go tumbling on polished surfaces.

## SELF-MOCKERY

While one is often amused at the expense of the two detectives, they too are capable of laughing at the absurd situations in which they sometimes find themselves. In *Explorers on the Moon* they find the time and the space suits to make a Moon walk. Delighting in the reduced gravity and the apparent impossibility of taking a tumble, they even perform "a little ballet", which provokes great mutual mirth. More often than not, however, their spasms of laughter presage another mishap. In *The Blue Lotus* they laugh at their last fall only to miss the stairs and come crashing down again. In *King Ottokar's Sceptre*, the hilarity over their fear of dropping into the sea precedes a fall … into the sea!

Detail from *Explorers on the Moon.*

## LINGUISTIC GYMNASTICS

The Thom(p)sons can cap their physical clumsiness, so reminiscent of the slapstick of the silent cinema, with linguistic contortion. Hergé would take as much care with the text as with drawing and his translators in different languages have tried hard to match the linguistic gymnastics of the original.

The Thom(p)sons are masters of sentence inflation and distortion, word jumbles and catchphrases such as "To be precise!" or "Mum's the word!" The two detectives are linguistically disturbed.

Detail from
*Cigars of the Pharaoh.*

## OMNIPRESENT

Their heroism before the firing squad in *Tintin and the Picaros* is not quite their final word, for they appear in Hergé's last unfinished adventure, *Tintin and Alph-Art*, which only exists in sketch form. There they arrive at Marlinspike and reveal they have information on a plot by "a Palestinian commando" to kidnap Emir Ben Kalish Ezab who is visiting the country. Among recently rediscovered pages of sketches and notes for this ultimate adventure is one where Hergé has noted in red ink: "Cause the two Thom(p)sons to intervene; they are on a case involving drugs; a ship that … (so as to put the reader on a false trail.)" If this scenario were to be followed, then the two detectives would have ended their role in *The Adventures of Tintin* in much the same way as they had begun some 50 years earlier. They would have come full circle – in the manner of their desert drive – in a career of misunderstandings and mishaps. ▮

Detail from *Tintin and Alph-Art.*

# Bianca CASTAFIORE

# One woman dominates *The Adventures of Tintin* ...
# a diva!

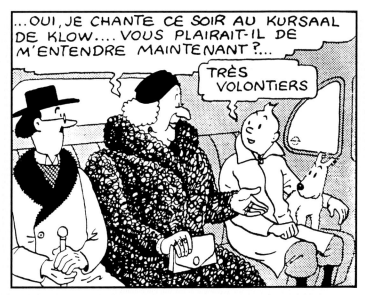

The first appearance of Bianca Castafiore.
Frame from *King Ottokar's Sceptre*.

One woman stars in *The Adventures of Tintin* and what a woman – Bianca Castafiore! Her name is writ large on opera playbills from Syldavia and Borduria in Hergé's vision of Central Europe to obscure South American republics, and includes, of course, that high altar of opera, La Scala in Milan. Although she first appears in the eighth adventure, *King Ottokar's Sceptre*, her strength of personality is such that like Captain Haddock, whose debut comes in the subsequent book, she becomes an integral and indispensable member of Hergé's cast. Even where she does not appear in person, for example in the fictitious Arab state of Khemed, in the Moon adventures or in Tibet, her reverberant voice is recalled (by Haddock in *Destination Moon*) or heard, thanks to the radio. To first Tintin's, then Haddock's consternation, there is no escaping her.

## FROM MILOU TO BIANCA

Hergé was something of a connoisseur of women, strongly attracted to and appreciative of the opposite sex. There was his first girlfriend Milou, Marie-Louise Van Cutsem, whom he knew from childhood and who inspired the name of Tintin's dog (Milou in French, Snowy in the English translation). Then there was Germaine Kieckens, the highly efficient and good-looking secretary of his employer at *Le Vingtième Siècle*, whom he married in 1932 after a long engagement. He would use her as a model for some of the alluring fashion sketches he produced for the newspaper and she can be spotted in a pink ball gown next to Hergé, himself in a green military uniform, at Tintin's investiture at the court of King Muskar XII. Later there were several younger girlfriends until finally he fell for a beautiful, talented and vivacious colourist working in his studios, Fanny Vlamynck, who became his second wife.

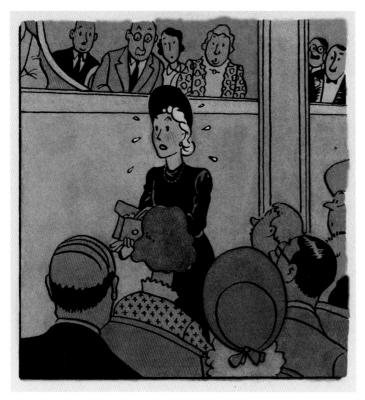

Mrs Clarkson, frame from *The Seven Crystal Balls*.

His portrayal of the unfortunate Mrs Clarkson in *The Seven Crystal Balls* is an example of how attractive Hergé's women could be. He gives her film-star looks that would certainly qualify her as a Hitchcock blonde.

Hergé's fascination with the fair sex, however, is not shared by Tintin, on the basis that in a fast-paced adventure brimming over with action there is hardly time for romance. Primarily written for children, the Tintin adventures were not, in Hergé's view, the place for any romantic attachments beyond the blushes of Professor Calculus when in *The Castafiore Emerald* we find he has fallen rather charmingly and unexpectedly for Bianca Castafiore, known as "the Milanese nightingale" on account of her association with La Scala opera house in Milan.

As in his approach with Tintin and Haddock, Hergé brings together a number of ingredients to form the character of Castafiore. First of all he had an aunt, Ninie, who during his childhood would regale the Remi household with her loud and shrill singing to piano accompaniment. Her performances did nothing to foster a love of music, let alone opera, in the young Georges Remi to match his early enthusiasm for drawing and later love of the visual arts. In fact, it probably contributed to

Frame from *The Seven Crystal Balls*.

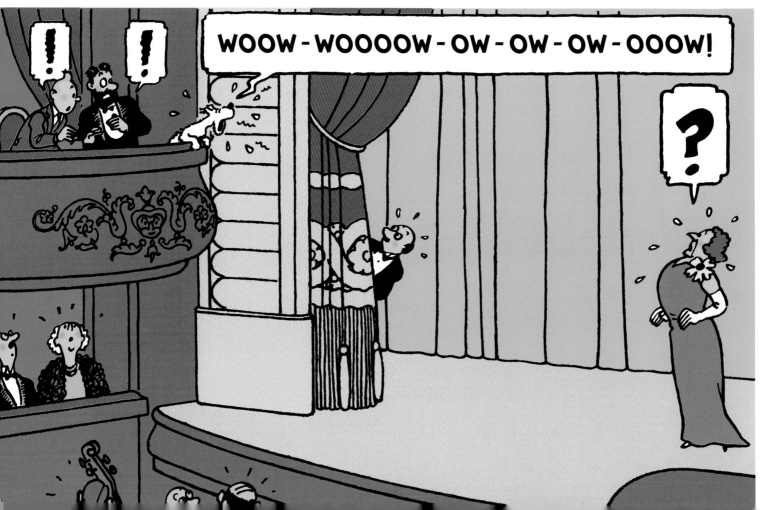

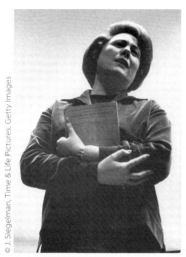

The Italian soprano Renata Tebaldi clutching her score during a rehearsal.

his inability to discover any appeal in opera, a form of artistic expression that he found rather ridiculous and beyond credibility. "Opera bores me, to my great shame. What's more, it makes me laugh," Hergé admitted. And so, perhaps not surprisingly, he creates an archetypal opera singer who makes us laugh. From this stereotype, which Tintin and his readers first encounter in *King Ottokar's Sceptre*, Hergé refines and develops the character of Castafiore as he deploys her in subsequent adventures. In *The Seven Crystal Balls* (1948), where her rendition of the Jewel Song forms part of the music hall programme, Castafiore as a woman remains singularly unprepossessing, bereft of any of her later glamour. She is clad in a long lilac evening dress, unflattering in the extreme as it strains over her massive bosom, while her hair – brown on this occasion – is downright dull. In short, there is nothing of the siren about her; she would lure no one.

## MARIA CALLAS, AS MODEL!

It was in the 1950s when the newspapers and news magazines such as *Paris-Match*, a favourite source of material, were full of the sensational opera career and private life of Maria Callas that Hergé found his real model for Castafiore. Born Maria Anna Sofia Cecilia Kalogeropoulou in 1923 in New York of Greek immigrant parents, she studied at the National Conservatoire in Athens, made her debut at the age of 15, and was engaged by La Scala Milan in 1951. The 1950s were Callas's golden years when she was winning worldwide acclaim for her legendary performances in Milan, New York, Chicago, London and Paris. By 1964 Sir David Webster, Director of London's Covent Garden Opera House, could describe her as "the greatest theatrical musical artist of our time." She was 'La Divina', arguably the world's most famous operatic soprano.

Yet among sopranos Maria Callas had one great rival: the purevoiced, Pesaro-born Renata Tebaldi (1922–2004), whom Italians affectionately liked to call 'la nostra Renata' and who, unlike Callas, specialised almost exclusively in the Italian repertoire, so the Jewel Song from *Faust* was a rarity in her repertoire. Hergé would have read of and been amused by their duels in the press.

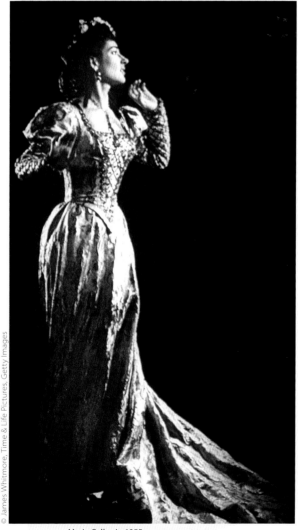

Maria Callas in 1955.

Bianca Castafiore in a selection of outfits.

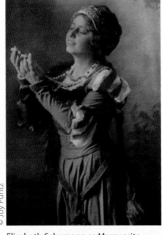

© Joy Puritz

Elisabeth Schumann as Marguerite singing the jewel aria from Gounod's *Faust* in 1917.

## À LA CALLAS!

Meanwhile from being the rather matronly and frumpy dramatic soprano first encountered in 1938–39, Castafiore becomes – à la Callas – super elegant and fashionable. She is rejuvenated and is certainly more attractive in *Tintin and the Picaros* (1976), than 38 years earlier at her initial meeting with Tintin in Syldavia. Such is the transformation that one should not be totally surprised by Professor Calculus's apparent infatuation with the diva in *The Castafiore Emerald*, where her statuesque form is shown to its best advantage in the latest creations of Tristan Bior (Hergé's parody of Christian Dior) and Chanel.

## A CELEBRATED ARIA

Her calling card aria – sung throughout the adventures – was typically an inspired choice by Hergé: the Jewel Song from Charles Gounod's grand opera *Faust*. Florid, dramatic, demanding the greatest virtuosity, it describes the moment in Goethe's tragedy when the young Marguerite finds the casket of jewels left by Mephistopheles, tries them on and, regarding her reflection in a mirror, is dazzled by what she sees. The music breaks into waltz time as she declaims: "Ah, my beauty past compare; these jewels bright I wear! Was I ever Margarita?" It was a great favourite of the Victorians and Edwardians – sung by Dame Nellie Melba among many others – and for at least the first half of the 20th century. In May 1963, the year of publication of *The Castafiore Emerald*, Callas recorded Gounod's jewel aria in the Salle Wagram in Paris with the Orchestre de la Société des Concerts du Conservatoire under Georges Prêtre. Real life was again echoing Hergé's world.

According to the stage directions for this particular moment in the opera, Marguerite is in a garden sitting at a spinning wheel singing a ballad before she is distracted. This explains Castafiore's extraordinary outfit in *King Ottokar's Sceptre* where she is attired as a medieval Teutonic maiden, complete with long blonde, plaited pigtails, as she sings for the broadcast from the Winter Garden at Klow.

Bianca Castafiore attired as a medieval Teutonic maiden in *King Ottokar's Sceptre*.

Detail from *The Seven Crystal Balls*.     The Paris Opera, from Hergé's archive.

Detail from *The Calculus Affair*.

By the time we reach *The Calculus Affair* (1956), however, we see her as an altogether more glamorous Marguerite welcoming Tintin and Haddock into her dressing room at the Szohôd opera house: "Come into my dressing room … Yes, yes … I can't leave my admirers in the passage … I've put on Marguerite's prettiest gown for you …" At an earlier curtain call, we saw among the opera house stall seats a disgruntled looking Snowy, his muzzle bound by a handkerchief, and Tintin having to rouse a comatose Haddock. But Castafiore with her indestructible immodesty declares: "You heard it? … Such a success, wasn't it? … One of the greatest triumphs of my career … What applause … especially for the Jewel Song … They were in ecstasies, weren't they …?"

Arriving at Marlinspike Hall early in *The Castafiore Emerald*, before even taking off her luxurious fur coat and matching hat, she presents Haddock with a pet parrot – "He's called Iago, a compliment to dear Signor Verdi …" – and Tintin with a long-playing gramophone record of, needless to say, her singing the Jewel Song in *Faust*. "I thought it would remind you of our first meeting in Syldavia. Do you remember?" she asks.

During her television interview at Marlinspike, Castafiore is asked which works she would be performing on her forthcoming "tour … or should I say, your triumphal progress." Always prone to flattery, the prima donna replies: "How well you put it! … Yes, as usual I shall be singing Rossini, Puccini, Verdi, Gouni … Oh, silly me! Gounod!" Composer by composer, it is a repertoire shared exactly with Maria Callas. "Ah, Gounod? Wasn't it in Gounod that you achieved your greatest success … made your name, in fact?" the interviewer continues. "Yes, the Jewel Song from 'Faust' swept me to the pinnacle of fame. They say I'm divine …"

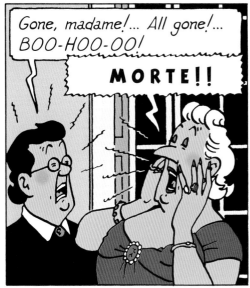
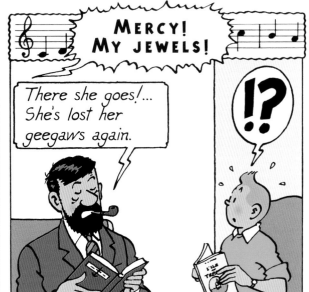

Frames from *The Castafiore Emerald*.

## A PASSION FOR JEWELS

While singing about jewels, like Maria Callas she has an obsession with them. The famous emerald central to the plot in *The Castafiore Emerald* is matched by any emeralds possessed by Callas, who was a passionate and discerning collector of fine jewellery. In fact, it bears a remarkable resemblance to a claw-set emerald (weighing 37.56 carats) and diamond ring auctioned by Sotheby's in Geneva in November 2004 – 27 years after the diva's death. Regarding Castafiore's emerald, we learn from her – between sobs – that it was a gift from the Maharajah of Gopal, a character who does not appear in *The Adventures of Tintin* but in the parallel *Adventures of Jo, Zette and Jocko*, which Hergé produced for a time in response to demands from his publisher for more family orientated stories.

In 1957 British society and fashion photographer Cecil Beaton portrayed Callas in a high-necked woollen top, resting her head on her elbows and cupping her face in her hands; a simple but intense image where the only concessions to extravagance are the rings on her finger. Similarly in *The Castafiore Emerald*, the diva's rings are always evident.

Beaton considered Callas "a supernova exploding into unparalleled brilliance." He found he was surprised by her physical appearance: "Miss Callas looks less like a singer than a smart woman playing bridge for high stakes. When she speaks Italian, she is an artist; but the myth is shattered the moment that Brooklynese pours forth. Then she becomes spoilt, pettish, bad-tempered, a hellion." He observed at the Paris Opera that if she sang a wrong note, everyone would boo but if she took her seat in the audience, the house would cheer.

The Maharajah of Gopal who gave the emerald to Bianca Castafiore, pictured here in *The Valley of the Cobras* from *The Adventures of Jo, Zette and Jocko*.

© Cecil Beaton Studio Archive, Sotheby's

Maria Callas photographed by Cecil Beaton.

There is an extraordinary parallel between Rastapopoulos and Onassis, here at their respective yacht radio sets. Frame from *The Red Sea Sharks* and photograph from Hergé's archive.

The iconic soprano and queen of 1950s high society was to accumulate further fabulous jewels during her nine-year-long liaison with the Greek shipping tycoon Aristotle Onassis, who became the very obvious model for the Marquis of Gorgonzola, the alias of the arch-villain Rastapopoulos, in *The Red Sea Sharks*, and his ostentatiously luxurious yacht the *Christina* inspired the Scheherazade on which Gorgonzola, with Castafiore at his side, entertains his celebrity guests.

## BIANCA, VAIN BUT COURAGEOUS

Hergé's files have abundant information and photographs on gems of every description – notably emeralds – and on Onassis' yacht, its extravagant fittings and its hectic party schedule. Then there are cuttings galore recording the frantic pursuit of Callas by paparazzi and gossip columnists in search of material on her affair with Onassis or her artistic tantrums – all richly drawn on in *The Castafiore Emerald* to reflect the duel between the diva and the press. On the one hand Castafiore professes to be persecuted by journalists and seeks refuge at Marlinspike Hall, on the other she cultivates them, basking in the attention.

Frame from *The Calculus Affair*.

Frame from *Tintin and the Picaros*.

For all her overpowering vanity, Castafiore displays two notable qualities in *The Adventures of Tintin*: her loyalty and her courage. When the villainous and lecherous Sponsz, reminiscent of the odious Scarpia in Puccini's opera *Tosca* – one of Maria Callas's great roles – gains access to Castafiore's dressing room in *The Calculus Affair*, his intentions are transparent. She is compromised by having Tintin and Haddock hidden in her wardrobe. Rather than give them away, she loyally conceals – at some risk to herself – their presence, explaining away the Captain's cap as belonging to the U.S. Navy Lieutenant Pinkerton in Puccini's opera *Madama Butterfly*, another Callas role.

Then, in the final completed adventure, *Tintin and the Picaros* (1976), Castafiore is positively heroic. While on a Latin American concert tour she is arrested by General Tapioca on trumped-up charges of involvement in a plot to overthrow his regime in San Theodoros. Her real courage is manifest when she stands in the dock at the Palace of Justice in Tapiocapolis. In a pink couture suit, broad-brimmed white hat heavy with flowers, she applies lipstick, completing her make-up as the Public Prosecutor rants: "For this siren with a serpent's heart, for this gorgon with a voice of gold, I beg, I implore, I demand, IMPRISONMENT FOR LIFE!" Refusing to be crushed, she shows her contempt for the absurd process by breaking into the Jewel Song with her customary brio: "Aaah! My beauty past compare!"

## RELUCTANT ROMANCE

While Professor Calculus's affection for her remains unrequited, Captain Haddock for all his resistance does seem to be more 'fortunate.' His accidents in *The Castafiore Emerald* bring out the prima donna's maternal instincts as she fusses over him, administering to his bee sting or pushing his wheelchair around the garden. It is hardly surprising that the 'Paris-Flash' (a thinly disguised *Paris-Match*) journalists sense romance and forthcoming nuptials.

There is the clinching moment in *Tintin and the Picaros* when liberated from her prison cell, holding an empty pasta plate, she rushes headlong towards Captain Haddock (or "Hemlock" as she incorrigibly calls him on this occasion!) undeterred by his carnival costume: "Come caro mio! … Come to my arms! I knew you'd come to rescue me from this dreadful place!" A tear rolls from her eye as she embraces the reluctant mariner and Hergé draws hearts around her like a halo!

Subconscious feelings, about which Freud would have much to say, clearly ran deep, for the next, final adventure, the unfinished *Tintin and Alph-Art*, begins with Haddock's nightmare of being roused by a grotesque harpy: part Castafiore, part hen/giant woodpecker. Hergé frequently had strange dreams, the details of which he noted down. Already in *The Castafiore Emerald*, Haddock dreams of a lilac-gowned parrot – wearing pearls! – singing the Jewel Song from *Faust* while he sits naked and blushing in the stalls surrounded by an audience of dinner-jacketed parrots! Soon after Haddock wakes, Tintin picks up the telephone that is ringing a second time after a wrong number (for Cutts the butcher, needless to say): it is Castafiore just back from Los Angeles. She has a new infatuation, for the mysterious guru Endaddine Akass – none other, it would seem, than Rastapopoulos in his final incarnation – but she does not forget to pass on "lots of kisses to dear Paddock" (as Haddock becomes this time). Later, with Castafiore acting as the hostess at Akass's villa on Ischia – in much the manner displayed on Gorgonzola's yacht Scheherazade – she plants a smacking kiss on Haddock's (or Kapstock, as she introduces him) bearded cheek as he arrives with Tintin.

If she feels love for Haddock, it is not exclusive. She lists in *The Castafiore Emerald* a number of admirers: "The newspapers have already engaged me to the Maharajah of Gopal, to Baron Halmaszout, the Lord Chamberlain of Syldavia, to Colonel Sponsz, to the Marquis of Gorgonzola, and goodness knows who." Like Narcissus, real love is reserved for herself. Poor Professor Calculus, who – despite his roses and old-fashioned chivalry – has no real chance of amorous success. He may have been able to conquer the Moon, but not that Milanese nightingale, Bianca Castafiore. ▐

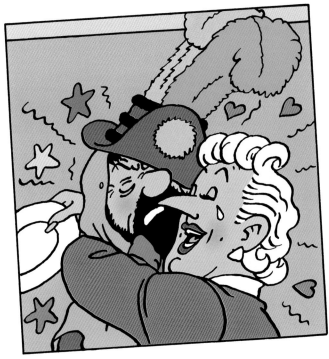

Frame from *Tintin and the Picaros*.

Frame from *The Castafiore Emerald*.

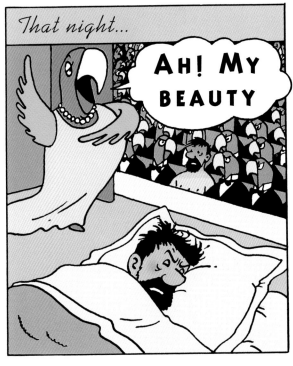

# CHANG

# A young Chinese boy changes Tintin's view of life ... and Hergé's of the world.

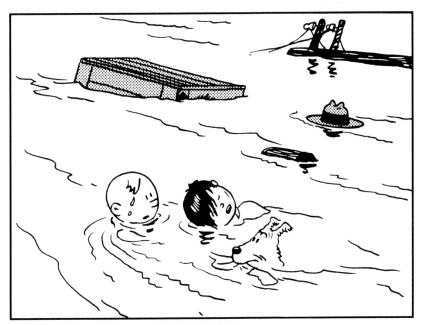

The first appearance of Chang.
Frame from *The Blue Lotus*.

The Chinese boy Chang has an importance in *The Adventures of Tintin* that far outweighs his modest though vital appearance in two of the books. Saved by Tintin from drowning in the muddy waters of the swollen Yangtze Kiang, he becomes almost a brother to the reporter.

## REALITY TURNS INTO FICTION

Meanwhile thousands of miles away in Brussels a close bond had developed between the then 27-year-old Hergé and Chang Chong-chen, an art student of the same age whom he had met as he embarked on a new adventure, *The Blue Lotus*, following on directly from *Cigars of the Pharaoh*.

Among the diverse cast of characters to be found in the adventures, a number inspired by contemporary figures or acquaintances, Chang is unique for being a close friend of Hergé and appearing as himself. Only one other real person plays himself – Al Capone in *Tintin in America* – and he was no friend of either Tintin or Hergé. Chang is also the only character from the Tintin stories whom I had the privilege of meeting.

Jesuit missionaries would wear long pigtails and conical hats, adopting Mandarin costume, as they sought to implant Christianity in China.

Born in Shanghai in 1907, Chang Chong-chen studied painting and sculpture in Brussels from 1931 to 1935.

Frame from *Tintin in the Land of the Soviets*, depicting the stereotype of the cruel Chinaman.

## THE QUEST FOR ACCURACY

It all began when a notice in *Le Petit Vingtième* announced that Tintin, at the time taking a well-earned holiday in India as a guest of the Maharaja of Gaipajama after the exertions of his last adventure in Egypt, Arabia and the subcontinent (*Cigars of the Pharaoh*), would shortly be setting out for the Far East, to China. It was spotted by a certain Father Léon Gosset, chaplain to the Chinese students at the University of Louvain, who wrote to Hergé to warn him of the dangers of repeating old clichés when portraying the Chinese and to offer him introductions to some of his students so as to give him a better idea of this distant land, ill understood by many Europeans. Hergé, well aware of this risk, shared the priest's concern and accepted his offer. Already in two brief passages in *Tintin in the Land of the Soviets* and *Tintin in America* (in the early black and white version, dropped in the later colour edition) he had fallen into the stereotype trap and included among the villains pigtailed Chinese torturers and executioners.

But Chang, all white men aren't wicked. You see, different peoples don't know enough about each other. Lots of Europeans still believe...

...that all Chinese are cunning and cruel and wear pigtails, are always inventing tortures, and eating rotten eggs and swallows' nests...

Frames from *The Blue Lotus*.

## CHINESE INITIATION

So through Father Gosset's offices, a meeting was arranged with Chang, who was studying sculpture at the Brussels Académie des Beaux-Arts and had a lively interest in painting, poetry and much else. The encounter was a complete success, greater than anyone expected, and soon Chang was able to guide Hergé through all the Sinological complexities of his new adventure, *The Blue Lotus*, set in China. In terms of providing the necessary realism for this ambitious adventure, the art student from Shanghai was offering the same succour to Hergé that Tintin gave to the character Chang. The real friendship that developed in Brussels was mirrored in the story. "But two of us would be far stronger ..." Chang says to Tintin. And so it was.

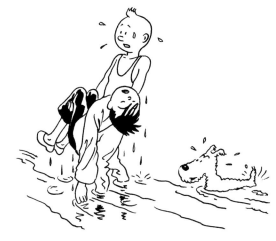

Detail from *The Blue Lotus*.

## A KEY WORK

*The Blue Lotus*, which began appearing in the pages of *Le Petit Vingtième* during 1934 and was first published in book form in 1936, marks a significant qualitative advance in Hergé's work. Without sacrificing an ounce of excitement, it has a cohesion, accuracy and depth that no Tintin adventure had so far achieved. The title does not come from Chang but, most probably, from the 1932 Josef von Sternberg film *Shanghai Express* starring Marlene Dietrich, where a telegram is received bearing the mysterious message: "Blue Lotus lost must have red blossoms midnight." Hergé was an avid cinema-goer. Botanically, a blue lotus is unknown.

Chinese drawing books given to Hergé by Chang.

## ORDER AND HARMONY

Hergé acknowledged the debt to Chang in interviews where he said Chang made him discover and love Chinese poetry: "The wind and the bone, that is to say the wind of inspiration and the bone of a firm drawing line. For me it was a revelation, I owe to him also a better understanding of the sense of things: friendship, poetry and nature." Chang introduced him to Chinese prints with their spare, vibrant line and subtle use of depth and space, and gave him Chinese drawing books and manuals to study and copy. "From there came my taste for order, my desire to reconcile detail and simplicity, harmony and movement," Hergé later explained.

Hergé was familiar with the film *Shanghai Express* where there is the mysterious mention of a 'blue lotus.'

The box of cigarettes featured in this advertisement in Hergé's archives was repeated on a wall poster he depicted in a Shanghai street.

Frames from *The Blue Lotus*.

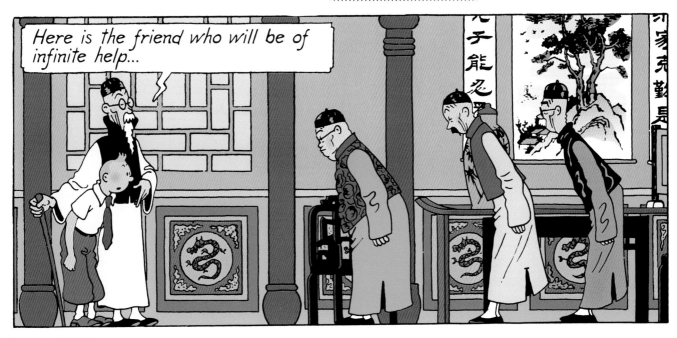

Frame from *The Blue Lotus*.

## CHINESE CHARACTERS

On Sundays Hergé would present Chang with his latest sheet of the adventure so he could write in all the Chinese names, on street signs, posters, advertisements, wall slogans, which he executed in his impeccable calligraphy often giving them political meaning. Among the more piquant is the wall slogan "Down with imperialism!" behind the appalling Gibbons as a furious Tintin snaps his walking stick in two after the industrialist abuses the rickshaw driver. Another exhorts "Boycott Japanese goods!" A poster advertising electric light bulbs has the inscription "Siemens Electricity." There is a shop sign advertising "Watch and clock repairs," and Tintin has tea at a table above which hangs a sign offering "Drinks and snacks".

Some are philosophical in the Chinese manner: "If you are ill you will not be able to realise your ambitions" or "To own a thousand acres of land is not equal to a good job!" Similarly a policeman directs Tintin in perfect Mandarin. Taken as a whole the linguistic and other local detail lends the adventure a wonderful, unprecedented authenticity.

## POINTS IN COMMON

In the archives of the Studios Hergé there are probably more preliminary pencil and ink sketches of Chinese faces, types, dress, architecture and activities than were executed for any other adventure, in addition to the usual newspaper and magazine cuttings that Hergé accumulated for reference.

Photograph in Hergé's archive taken from *Von China und Chinesen* by H. von Perckhammer.

Chang the artist cut an elegant figure.

While it can be assumed that most of the drawings are by Hergé, some may be by Chang. When asked much later if he could say which, Hergé admitted he could no longer remember and was not absolutely sure.

The two men were remarkably similar types, modest with a deep-rooted sense of humour, boundless enthusiasms and fascination for the world around them. They attached great importance to appearance and were both dapper dressers, as can be seen in contemporary snapshots of them together. Chang was especially fond of his yachting cap that he would wear at a jaunty angle. It resembles the cap worn by the gun-running captain who rescues Tintin from a watery grave in *Cigars of the Pharaoh*, and the headgear of three of the scientists departing with the Aurora in *The Shooting Star*. Photographs of the real Chang reveal the likeness with Tintin's new friend.

## IN SEARCH OF CHANG

Chang Chong-chen, a Jesuit-educated Christian who had arrived in Brussels in late 1931 to pursue his artistic studies, returned home to Shanghai in 1935 to be lost in the maelstrom of 20th century history as Japan launched a wholesale invasion of China (already anticipated in *The Blue Lotus*), World War erupted and Communist revolution then swept the Chinese mainland.

Drawing by Hergé from his sketchbook.

Hergé made a point of studying numerous documents to ensure that his story was rooted in reality. Here, a photograph of Japanese soldiers in Shanghai in 1937.

Frame from *The Blue Lotus*.

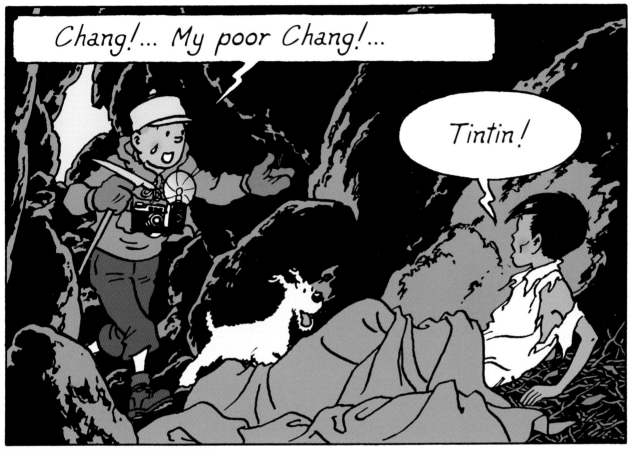

Frame from *Tintin in Tibet*.

By an extraordinary coincidence the day Chang embarked for Europe from Shanghai – September 18, 1931 – was the very date that Japanese agents blew the railway at Moukden – the so-called 'Moukden incident' – which the Japanese used as an excuse for the invasion of Manchuria, an episode dramatically depicted in *The Blue Lotus*.

For 40 years Hergé lost contact with, though never forgot, his Chinese friend. From time to time he made enquiries which led nowhere until one evening in 1975 he asked a Chinese guest at a dinner party whether he knew a Chang in Shanghai. He scratched his head and thought he might, and said he would ask his brother to check. Soon it was confirmed that Chang Chong-chen was alive and, despite the trials and buffeting of the Cultural Revolution, was continuing with difficulty to practise as an artist at the same family home he had returned to in 1935!

Hergé was overwhelmed. Life was again imitating art, for in 1960, while going through an acute personal crisis with the breakdown of his first marriage, Hergé revived memories of Chang for his most poignant adventure, *Tintin in Tibet*, where the reporter is convinced despite the improbability that his erstwhile Chinese friend is still alive, a survivor of an air crash in the Himalayas, and sets out to find him. It is a tale of friendship – of Tintin and Chang – and of the bond between the Chinese boy and the yeti, or "abominable snowman," who saves his life. "I knew I'd find you in the end! This is wonderful!" … "Tintin! Oh, how often I've thought of you!"

Carefully kept by Chang,
Hergé's letter of May 1, 1975.

Chang's letter to Tintin.
Frame from *Tintin in Tibet*.

## REDISCOVERY BY LETTER

Similar sentiments were to emerge 15 years later when Hergé sent off that first letter to Shanghai on Chang's rediscovery, the address carefully written in Chinese by the friend who had traced him, the envelope looking strangely like the one received by Tintin from Chang at his alpine holiday hotel in the opening pages of *Tintin in Tibet*. "My dear Chang, What a joy to be able after so many years to write once more those three words: my dear Chang!" Hergé began the letter, dated May 1, 1975. He said that under a separate cover he would be sending two books, the colour edition of *The Blue Lotus* and *Tintin in Tibet*, where he would see how Tintin rediscovered Chang. "Isn't that a curious anticipation of what has just happened in reality? For my part, I never lost hope of finding you again one day and being able to express my enduring friendship and sincere gratitude. I stress gratitude. Not only for the help you gave me at the time, in my work, but also and above all for everything you brought me without knowing it. Thanks to you my life took a new direction. You made me discover so many things: poetry, the feeling of the unity of man and the universe. I can still see and hear you explaining the life of a tree growing behind our house, the day you came to visit us … Thanks to you, I finally discovered – some time after Marco Polo! – China, its civilisation, its thinking, its art and artists." He added that he was currently immersed in Taoism, something for which Chang could also take credit, and had recently decided to learn Chinese. He signed the letter "with my old, faithful and solid friendship, Georges Remi." Just as Chang remained a westernised Chinese artist from his Brussels student days, so Hergé was profoundly orientalised by their encounter and drawn to Chinese philosophy and ideas.

## THE POLITICAL BARRIER

While Hergé's excitement may have been great, the political situation in communist China remained difficult in the final days of Mao Tse-tung, who died in 1976, and the subsequently brief rule of the so-called 'Gang of Four' in 1977, followed by the acces-

sion to power of Deng Xiaoping and the institution of economic reforms from 1978. There was no question yet of any relaxation, any opening to the West.

The books promised by Hergé had the greatest difficulty reaching Chang. The first parcel disappeared completely, the second was returned to Brussels weeks later stamped 'Prohibited Import.' Finally only after Hergé made representations to the Chinese embassy stressing the cultural nature of the contents and its value for Sino-Belgian relations, did he manage to get a package through which Chang could pick up after completing interminable paperwork. Hergé, meanwhile, put in an application for a visa to visit to China. However, his lobbying was less successful in this case. The Chinese authorities did not view favourably his visit in 1973 to Taiwan – taking up a long-standing invitation from the widow of the late nationalist leader Chiang Kai-shek who appreciated the pro-Chinese stance espoused at the time by *The Blue Lotus*.

The months passed and turned into years, and while the correspondence between Hergé and his rediscovered friend proceeded at regular intervals and Chang's situation improved, there seemed to be no immediate prospect of a visa.

## CHANG RETURNS

Elaborate celebrations marking Tintin's 50th birthday in 1979 came and went, leaving Hergé exhausted but also, as became increasingly clear, seriously ill. Even if a visa finally came, it was doubtful whether physically he would be able to take it up.

If there was to be a reunion with Chang, something had to be done swiftly. A leading Belgian television journalist, Gérard Valet, decided to seize the initiative and sought to tackle the problem the other way round – by bringing Chang to Brussels. This approach was far from straightforward but by lobbying hard, promising his financial backing and eventually paying for the flights, Valet succeeded, and brought Chang, accompanied by his son Xueren, to Brussels on March 18, 1981.

Chang in his studio in 1981.

Chang's house in Shanghai's He Fei street, previously in the French quarter of the International Settlement. His studio took up much of the building.

Hergé was very weak and tired from the cancer of the blood that was to kill him two years later but promised that he would be at Brussels' Zaventem airport with his wife Fanny to meet his old friend.

The press were out in force for the biggest event in the world of Tintin – who by now had become an international figure – since the reporter's return from the Soviet Union or the Congo some 50 years earlier. There were even more journalists than had greeted Tintin on his return to the mainland from the Black Island, or who came to Marlinspike for the photo-film opportunity with Bianca Castafiore, or to quiz Captain Haddock about General Tapioca's absurd plot accusations in the last of the adventures to be completed.

## MORE THAN FRIENDS

Chang, fatigued from his long journey and overwhelmed by the media interest, and Hergé putting a brave face on his illness, were compelled to give a press conference on top of all the formalities and introductions. Hergé told the reporters that Chang was "more than a friend" and how "he opened many doors and windows for me."

Their first embrace was as tearful as the parting of Tintin and Chang had been at the end of *The Blue Lotus*. It was a tremendous strain and only when they returned later to Hergé's home could the significance of their reunion after 46 years sink in.

Chang's easy nature made him a willing participant in a range of events demanded during his Belgian visit, in addition to the constant book signings of *The Blue Lotus* and *Tintin in Tibet*. Having been declared a non-person during the terror of the Cultural Revolution and barred from signing any work, he was now being fêted in the country where he had studied, his signature demanded everywhere. During the three-month stay – which the Chinese authorities refused to extend – he found time to complete a sensitive portrait bust of Hergé. Captivated by his visit, he was determined to come back soon and return he would, but not before the death of his great friend.

The reunion at Brussels' Zaventem airport in March 1981.

A tribute to their friendship, Chang models a portrait bust of Hergé that was later cast in bronze.

Frame from
*The Blue Lotus.*

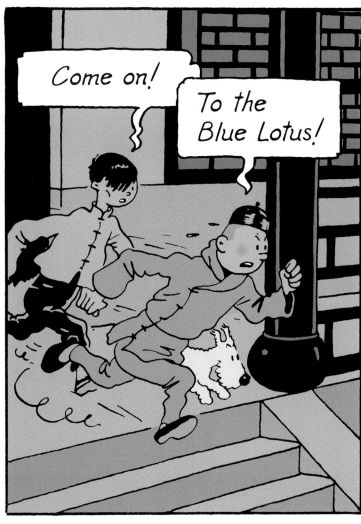

Left and below, drawings by Hergé
from his sketchbook.

## ARTISTIC RECOGNITION

In Shanghai the recognition he had achieved before the dark days of the Cultural Revolution was re-established[1] and he was able to complete important sculptural commissions. However, despite his advancing age, Europe beckoned and notably the French government in the person of Culture Minister Jack Lang who offered work and a studio in the Paris suburb of Nogent-sur-Marne. Lang commissioned a large head of Hergé – a final tribute to their friendship – for Angoulême, and President Francois Mitterrand sat for an official portrait bust. France's most notable post-war president, Charles de Gaulle, had been a great admirer of Tintin, once declaring him to be his "only international rival!"

Apart from the two adventures he appears in, there is a passing reference to Chang in *The Castafiore Emerald* when Tintin opens a letter at Marlinspike. "A letter from Chang in London: he's fine, and sends you his regards," Tintin tells Haddock. "What a nice lad he is," the Captain observes.

Chang was to outlive the creator of Tintin by over 15 years, dying peacefully at Nogent, where he is buried, in October 1998 at the great age of 91. Like all artists, he lives on in his own work, but also in that of his friend Hergé.

1 In 1979 Chang was appointed director of the studio of painting and sculpture at the Academy of Fine Arts in Shanghai.

# ABDULLAH

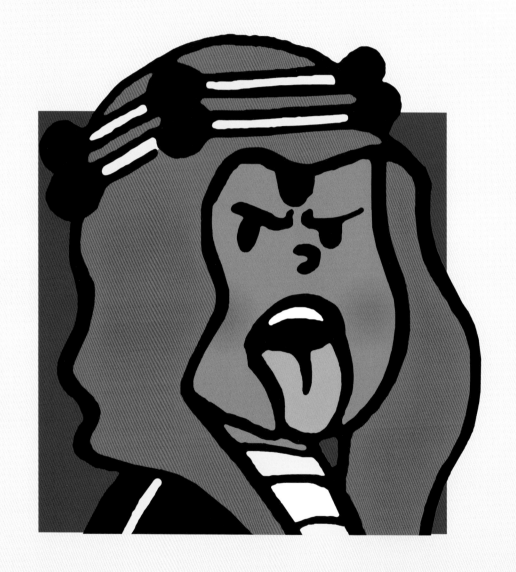

# A mischievous little devil, impertinent and incorrigible, a delinquent afraid of no one!

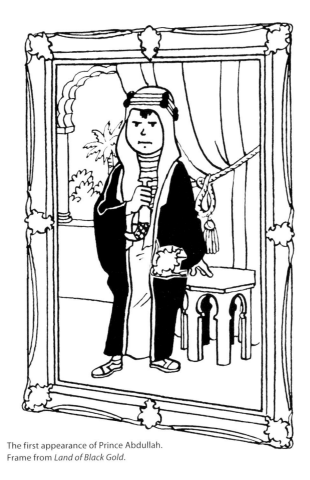

The first appearance of Prince Abdullah. Frame from *Land of Black Gold*.

King Faisal I of Iraq. Iraq was delineated and placed under British mandate from 1920 to 1930, declared a kingdom in 1921, and gained independence in 1932. King Faisal I was a co-founder of the Arab League in 1945.

Ibn Saud, founder and King of Saudi Arabia (1932–53).

Hergé's fascination with the Arab world to which he despatched Tintin on a number of occasions saw him accumulate a variety of relevant material from newspapers and magazines. There are photographs of mosques and holy places showing elaborate Islamic decorative schemes; there are minarets and market places and, of particular inspirational value, pictures of the Arab princes ruling these desert kingdoms, newly established following the Versailles peace conference and the break-up of the Ottoman empire. Out of this bulging dossier, he could pick and choose models for the Arab characters he was to create.

For Abdullah's doting father, the Emir, Hergé relied on press photographs he had of two Arab kings: appropriately King Faisal I of Iraq, comrade-in-arms of Colonel T.E. Lawrence during the Arab Revolt against the Turks and grandfather of the young Prince Faisal, and Ibn Saud, the founder of Saudi Arabia. For the emotionally volatile ruler of fictional Khemed, Hergé drew on both.

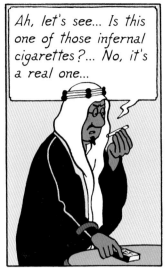
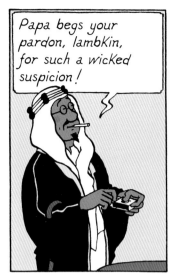

Frames from *Land of Black Gold*.

King Faisal II of Iraq who ascended the throne of the oil-rich kingdom aged four and was the obvious model for Hergé's Abdullah.

## A PRECOCIOUS YOUNG MODEL

Among Hergé's gallery of Arab characters, none is more memorable than Prince Abdullah, whose besotted father, Mohammed Ben Kalish Ezab, admits is "the naughtiest young rascal anyone ever saw!" For this "adorable" little pest, Hergé chose as his model a photograph he had of the young King Faisal II of Iraq aged, like Abdullah, about six. Hand clutching the handle of a ceremonial dagger, berobed, wearing Arab headdress and sandals, the pose is copied carefully in the formal portrait of Abdullah that is the reader's first view of the rascal Prince.

There was additionally a prototype for the inexhaustible repertoire of tricks, pranks and practical jokes perpetrated with such relish by Abdullah. Parallel to Tintin, Hergé had in January 1930 begun a strip cartoon with a pair of mischievous Brussels street urchins, Quick and Flupke, which enjoyed considerable popularity.

Cover illustration announcing the start of the exploits of Quick, the Brussels street urchin, *Le Petit Vingtième*, January 23, 1930.

Detail from *Land of Black Gold*.

There may have been a marked similarity in appearance between the young Faisal and the Abdullah encountered in the adventures of Tintin, but their characters could not have differed more. While the hopelessly spoiled Abdullah was an incorrigible, irresponsible prankster, for whom only his father and occasionally Captain Haddock had a soft spot, Faisal showed a maturity and responsibility beyond his years. In 1942, the society and fashion photographer Cecil Beaton was sent to the Middle East as a war correspondent. In Baghdad he photographed and was impressed by the seven-year-old king, whom he found "a really touching little boy with tremendous gravity, sense of responsibility, manners, charm and intelligence."

## THE DELINQUENT ABDULLAH

On every count then, Faisal was the very opposite to the delinquent Abdullah who on first coming across Tintin in *Land of Black Gold* squirts him with a soda siphon, then bites his hand! It only takes four more frames, for an exasperated Tintin to administer – behind a closed door – eight of the best! He leads out a chastised Abdullah clutching a sore bottom and exclaiming: "I hate you! … I shall tell my papa! … And my papa is the Emir… And then he'll cut off your head … and play skittles with it … So there!" Later it is Captain Haddock's turn to bend Abdullah over his knee and give him a good spanking – to little effect! Faisal, however, was clearly properly brought up, with an English nurse and a Scottish governess charged with his upbringing and education.

© Cecil Beaton 1942

Cecil Beaton took photographs of the precocious boy king perched on the side of a throne that was far too big for him, off-centre from the central crowns embroidered on the chair back and the curtain behind.

Frames from *Land of Black Gold*.

## ABSENT BUT REMEMBERED

Abdullah's debut in *The Adventures of Tintin* comes halfway through the sequence of books. The Prince or his practical jokes feature subsequently in *Destination Moon*, *The Red Sea Sharks*, *Tintin in Tibet*, and he was pencilled in dispensing at least one firework and exploding cigars in the unfinished *Tintin and Alph-Art*. Once Hergé created a character, he liked to bring him back – to the reader's delight – at an appropriate though often surprising moment. In *Destination Moon*, for example, there can be little doubt that the jack, or snake-in-the-box camera used by Captain Haddock to shock Calculus into his senses was acquired, or confiscated, from Abdullah. In the original French Captain Haddock admits as much. It is the sole reference to the practical-joking Prince in this adventure. Similarly, in *Tintin in Tibet* he is referred to without making an appearance. Over breakfast on the hotel terrace, Captain Haddock asks Tintin: "But, I say … this Chang, he's not like that little monster Abdullah, is he?"

Frame and detail from *Destination Moon*.

## A TERROR FROM START TO FINISH

Finally, the scenario and sketches that Hergé produced for *Tintin and Alph-Art* include a sequence at Marlinspike where Tintin and Haddock watch a television interview with Abdullah's father, the Emir, which culminates in a bang – not the terrorist attack feared by Tintin, but a firework let off by the Prince to scare the interviewer! The next frame sketched by Hergé shows the Emir scolding his precious son. Shortly afterwards the Thom(p)sons arrive, bearing Havana cigars given to them by the Prince. They offer Haddock one and help themselves to a couple. Needless to say, first the detectives and then, after much hilarity at their expense, the Captain, have explosive experiences!

From his first to last appearance, covering a period of some 30 years, Abdullah does not change or reform. He remains an infuriating six-year-old with a recurring repertoire of practical jokes. We first hear of him during Tintin's audience with the Emir in *Land of Black Gold* when a distraught servant interrupts: "Oh, Master! Master! … Your son! …" To which the Emir replies: "Well, Ali Ben Mahmud, what new prank is my little lamb playing this time?" For once Abdullah is not up to one of his tricks. He has been kidnapped. However, there are plenty to follow, beginning with the sneezing powder that afflicts his sorrowing father, an exploding cigar for his chief military adviser, followed by an explosive cigarette for the Emir: "By the beard of the prophet! That wretched little centipede has changed all my best Sobranies for his filthy joke cigarettes!…" Shortly afterwards, as the Emir proudly shows Tintin the latest portrait of the Prince, he lights another cigarette after carefully checking that it is the genuine article, whereupon a spider springs out of what turns out to be a trick matchbox!

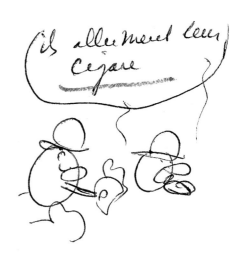

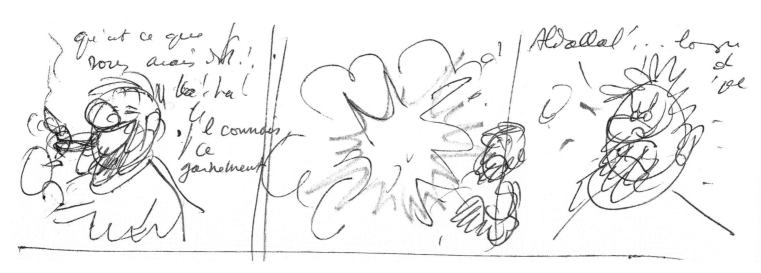

Details from *Tintin and Alph-Art*.

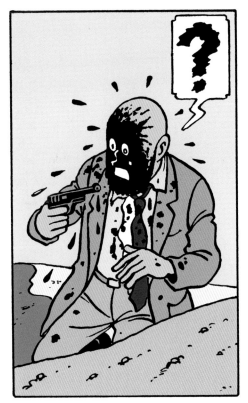

Frame from *Land of Black Gold*.

Two frames from *The Red Sea Sharks*.

As he leaves, Tintin inadvertently steps on something and there is another bang. "Take no notice," advises the Emir, "Just a cap … Abdullah scattered them everywhere … They liven things up in the palace …" Next it is the turn of Abdullah's kidnappers and eventually Tintin to fall victim to his sneezing powder. During the desert chase that follows, Abdullah pours itching powder down the neck of Dr Müller, alias Professor Smith, causing his car to plunge off the track and crash in flames. Müller's determination not to be taken alive ends ignominiously with him being covered in black ink when it turns out Abdullah has given him a fake gun – his ink pistol. Finally, yet another exploding cigar prevents Haddock explaining his involvement in the rescue. "Another of Abdullah's little tricks! … And he promised me he'd be good!" his father says indulgently. "Ah, what adorable little ways he has!"

It is all quite exhausting, not only for Captain Haddock and other victims of the Prince's pranks. So, apart from Haddock's purloining of the snake-in-the-box camera in *Destination Moon*, readers are spared Abdullah until he comes into his own again in *The Red Sea Sharks*.

## ABDULLAH AT MARLINSPIKE …

A Middle East crisis leading to a coup in fictional Khemed sees Abdullah and his entourage arrive unexpectedly at Marlinspike. The Emir himself is forced to flee to a desert hideout. The first we know of the unexpected development is on page 4 when a whimpering Snowy, forced into a red cap and pink gown, comes out of the front door as Tintin and Haddock approach. Seconds later a bucket of water crashes onto the Captain as he pushes open the door and a tiger mask accompanied by a roar give him and Tintin a terrifying welcome. It is, of course, Abdullah, come to stay. He has brought a present – a cuckoo clock – for the captain or "Blistering Barnacles", as he likes to call him, and the soft-hearted Haddock is touched until the cuckoo squirts him with water. Barely recovered from that shock, he has his pipe shot from his mouth by Abdullah taking a pot shot with a toy pistol. But worse is to come when a distraught Nestor leads him to the staterooms where Abdullah's party have struck camp, put up tents and are calmly roasting a chicken on a spit and smoking their hookahs.

The Thom(p)sons arrive and have old newspaper stuffed into their bowler hats so that they no longer fit; Tintin has an alarm clock compromisingly slipped into his coat pocket, and is then ambushed by Abdullah armed with a water pistol. Meanwhile, Captain Haddock's siesta is disturbed by a firework placed under his chair and then, as the last straw, he sees his pipe explode! The time has come for Tintin and Haddock to leave Marlinspike and Abdullah behind and seek relative "safety" in revolutionary Khemed.

Frame and detail from *The Red Sea Sharks*.

The unfortunate butler Nestor stays behind with the abominable Abdullah and his clan. When Tintin and Haddock find the Emir, he immediately asks after his "little treasure". "Rest assured, he is in good hands," Tintin replies. Next we see Nestor bound and gagged, a feather duster down the back of his neck as Abdullah "plays" with him. "Confounded brat!" Nestor thinks.

## AN UNPREDICTABLE END

Tintin and Haddock return to find a desperately ill-looking and emaciated Nestor: "I … I fear that Master Abdullah's visit was not very good for me…" Haddock reads a note the Prince has left: "My dear Blistering Barnacles, I have been very good. I haven't played any jokes. Papa wrote to me. I must go home. That's sad, because it is fun at Marlinspike. With love from Abdullah." Of course, the soft-centred Haddock is enchanted and, as he prepares to sit on his fine Louis XV armchair, says to Tintin: "Very sweet, eh?" A tremendous bang follows as sitting down, he detonates one of the infernal Abdullah's fireworks.

A last glimpse of Abdullah comes in the rough sketch in *Tintin and Alph-Art* where he is told off by the Emir for letting off a firework during the television interview.

Meanwhile, Abdullah's model, the young King Faisal II, came to a tragic end. In 1958, aged 23, he was together with his uncle and prime minister shot dead in his palace in Baghdad, in a coup led by General Kassem that overthrew the monarchy. ▮

# Jolyon WAGG

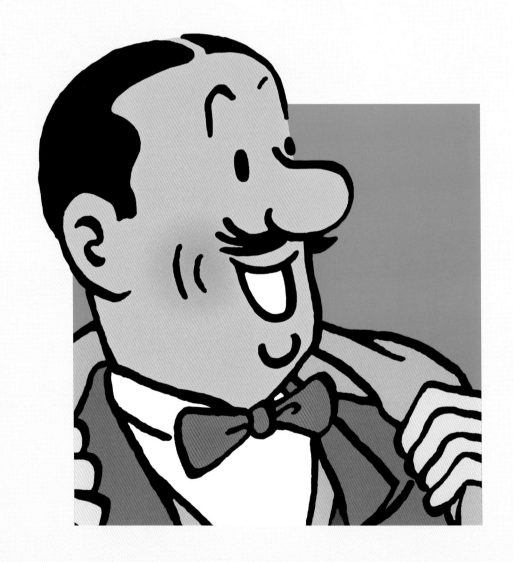

# Take cover! Wagg's coming! Or, how a plump insurance salesman can upset the tranquillity of Marlinspike ...

The tumultuous appearance of Jolyon Wagg.
Frame from *The Calculus Affair*.

Hergé in 1956.

© Némerlin

**A**mong the delights of *The Adventures of Tintin* is Hergé's ability to echo the world at large in all its diversity, not only places but particularly people. In his ever-expanding cast list he lacked, until *The Calculus Affair*, one type – the proverbial bore.

### THE SELF-SATISFIED BORE

However, with the creation of the smug, self-satisfied Jolyon Wagg he introduced a champion bore, one to beat all contenders for the trophy of tiresomeness. We are all too familiar with the type, easily encountered in pub or railway carriage. Captain Haddock is unlucky that such a ghastly specimen should barge into his elegant stately home, Marlinspike Hall. "Nice little place you've got here. Must say I prefer something more modern, but still ... Oho! Had a tiff with the wife, eh?" the lilac-suited monstrosity says impertinently, observing Captain Haddock's shattered Florentine mirror. "Is that whisky you're drinking? You can pour one for me while you're about it. Not that I like the stuff: I'm just thirsty, that's all." Installing himself, glass in hand, in a superb Louis XV chair after draping his jacket casually on its wing, he goes on:

"Not bad armchairs, these. I don't stand on ceremony, you know. A bit of a clown, that's me. Never a dull moment with me around, you bet!" His boundless, baseless confidence, his supreme vulgarity, the infuriating fixed grin and endless monologues are enough to exasperate not only Captain Haddock. Then as a bonus there are all the uncalled-for anecdotes of his Uncle Anatole, suitably a hairdresser or barber, a profession notable for its perceived conversational skills.

## A KEY SECOND ELEVEN CHARACTER

After much thought Hergé came up with the name Lampion – meaning a Chinese lantern – for his new character. As usual he listed various possibilities, including Crampon – a spiked appliance attached to boots for ice climbing. This would have had the advantage of a further meaning in French. The expression "Quel Crampon!" translates most appropriately in this case as "What a leech!" However, he rejected it as too explicit and hard sounding, and settled on Lampion. His English translators, Leslie Lonsdale-Cooper and Michael Turner, had a hard task finding a suitable equivalent and did well to pick Wagg. Hergé gave him the splendid first name Séraphin; in English this becomes Jolyon. As for his employer, the English translators' "Rock Bottom Insurance" may even be an improvement on the French "Assurances Mondass".

Hergé's portrait is so compelling that one seeks its inspiration. "It was some time ago that I found my model for Lampion," Hergé told Numa Sadoul. "During the war when I lived in Boitsfort, I received a visit from a character who wanted to sell me I no longer know what. He took a seat and pointing out my chair said: 'Do take a pew!' The unwelcome visitor in all his glory! He exists in thousands of examples: a typical Brussels type – and not only Brussels – who is smug and self-satisfied. They are exported in great numbers! During the holidays, they descend in tightly-knit hordes on foreign countries."

This is, of course, exactly what Wagg and his frolicking "Jolly Follies" do in *Tintin and the Picaros*. As Wagg steps off the tour coach in the middle of the tropical forest, he spies Haddock: "Blow me, look who's here! … Doctor Livingstone, I presume!" They can be disruptive at home too, as on the last page of *The Red Sea Sharks* when Wagg and his "Vagabond Car Club" descend like a plague on Marlinspike.

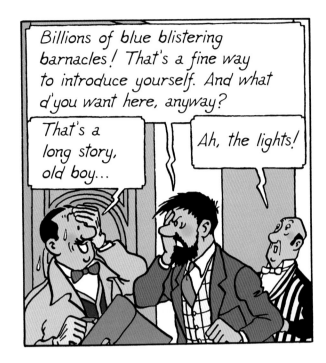

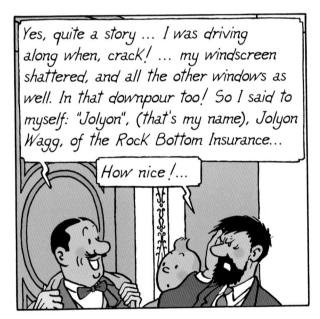

Frames from *The Calculus Affair*.

On the margin of drawings for *The Calculus Affair*, Hergé noted ideas for the ebullient insurance salesman's name.

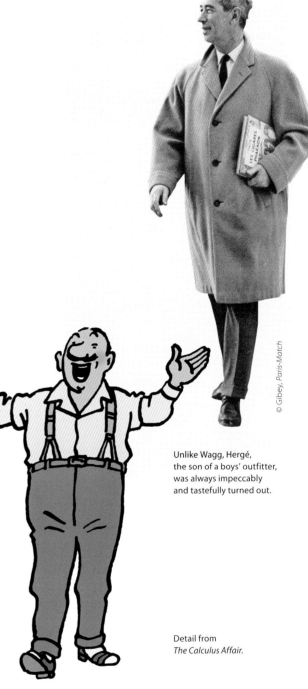

© Gibey, Paris-Match

## A MODEL OF BAD TASTE

Hergé noted that one of the hallmarks of this Brussels or Belgo type was "the wearing, at the same time, of a belt and braces," double security that might seem highly suitable for an insurance salesman who embodied all the hallmarks of vulgarity Hergé hated: tasteless dressing, over familiar behaviour, an atrocious moustache and a pimp's centre hair parting. Here was a type that Hergé detested and could characterise with memorable humour in almost half a dozen of *The Adventures of Tintin*. Captain Haddock was not alone in finding such an "ectoplasm" insupportable.

## HIS GHASTLY FAMILY

Hergé did not, however, go as far as finding him repugnant: "He is not a malicious man, but he is very pleased with himself and therefore exasperating. His family is ghastly: the wife, the children, the mother-in-law, that whole small world is frightful! They ransack Moulinsart [Marlinspike]. Dreadful, I tell you!" The last two pages of *The Calculus Affair* demonstrate how frightful. Haddock leads Tintin and Professor Calculus up the front steps of Marlinspike. "Ah, what a relief to be home again!" and promptly is struck on the head by a large beach ball before he tumbles over a wooden train set. A brat stands screaming: "DADDY! … DADDY! … There's a great big man with a beard breaking my toys!" And who should stride confidently forward in shirtsleeves, belt and braces, but Jolyon Wagg, who uninvited has installed himself at Marlinspike for the rest of the holidays with his "little brood" comprising wife, mother-in-law and seven frightful children (including twins). Laundry is drying on a washing line strung across the salon, a dartboard has been put up on the pockmarked wall, the baby is crying in the perambulator and poor Nestor, forced into a Red Indian feather headdress, is being ridden like a horse by one of the toddlers. Marlinspike was not to suffer anything so appalling until Abdullah and his Arab entourage camped in the state rooms in *The Red Sea Sharks*.

Unlike Wagg, Hergé, the son of a boys' outfitter, was always impeccably and tastefully turned out.

Detail from *The Calculus Affair*.

## A CHATTERING FUNK

Like many braggarts, Wagg is also a coward. He is visibly perturbed when his whisky glass shatters for no apparent reason and takes it as a cue to put on his jacket and coat and leave (page 6, *The Calculus Affair*). A couple of pages on Tintin and Haddock find him cowering in the bushes in the park of Marlinspike, claiming that he had been shot at: "Mercy! Have pity! Please don't kill me! I wouldn't harm a fly … I'm just a simple fellow …" Finally, one mention of chickenpox by Professor Calculus, and he packs his bags and hastily departs from Marlinspike with his awful clan.

We discover mid-adventure that as well as being a motor rally enthusiast and fan of folk dancing, Wagg is also an insufferable radio ham. Tintin and Captain Haddock are giving chase in a helicopter to a speed-boat racing across Lake Geneva with Syldavian agents who have abducted Professor Calculus. The helicopter is raked with machine-gun fire and in desperation Haddock uses the radio to try to alert the police. His signal is picked up by an unexpected radio buff: "This is Jolyon Wagg of the Rock Bottom Insurance … Blow me! … Fancy meeting you again! So you're another radio-amateur? Ha! ha! ha! That takes the biscuit, as my Uncle Anatole used to say…" Over two pages Haddock tries to impress on him the seriousness of the situation and the urgency of contacting the police, but it is hopeless. "Ha! ha! ha! Still keeping up the commentary! You know, you're an absolute wow at the mike, Captain!"

Frames from
*The Castafiore Emerald.*

## UNWANTED INSURANCE

As a further irritant, Wagg endeavours to sell unwanted insurance policies. He returns to Marlinspike with an unfunny "HANDS UP!" after Tintin and Haddock have had a brush with a Bordurian secret agent. "Now then, this'll cheer you up: I've brought your insurance proposal." They have no time for him as he delves through sheaves of documents in his briefcase. He gets equally short shrift from the conveniently deaf Calculus at the end of the adventure when he suggests insuring his laboratory.

## A FROST FROM THE DIVA AND ADIEU MARLINSPIKE

It is insurance that brings him back to Marlinspike in *The Castafiore Emerald*. Tintin returns from a walk to find the purple-suited Wagg ensconced comfortably in one of the period chairs, enjoying a cigar and beer as Haddock and Castafiore are subjected to his monologue: "Her jewels, her famous jewels, aren't even insured! What about that? A proper carry-on, eh? … She's got one little sparkler, an emerald… Given to her out East by some character … Marjorie something or other …" "Maharajah … The Maharajah of Gopal," Castafiore interjects. "Not a single jewel covered. So I said: 'Lady, you give me a list of your knick-knacks, and Jolyon Wagg will insure the whole shoot!'…" Castafiore, whom he calls "Duchess", is pained by his vulgarity and on his return with the policy, she gives him a withering look and does something that was long overdue – she slams the heavy doors of Marlinspike in his face.

Me too. Just the same. Only I'd call it a horrible nightmare.

Blow me! Look who's here again. My old chum! The ancient mariner from Marlinspike!... The old humbug, he doesn't half come up with some comic turns!

Frame from
*Flight 714 to Sydney.*

## HOME SWEET HOME

With Marlinspike for the time being spared his presence, we next find Wagg in the petty bourgeois awfulness of his own home, in front of the television with his ghastly family in a dark and dingy 'living' room at the end of *Flight 714 to Sydney*. He has shed jacket and collar and sits contentedly installed in his favourite armchair, a full glass of beer in hand and two empty bottles next to him, puffing a cigarette. At home he is clearly very much king of the castle, treated with dutiful, undue respect. His wife, hair in curlers and babe in arms, is to one side, two teenaged offspring on the other, and behind the mother-in-law knits. Readers are treated to Wagg's facetious commentary as he watches the "Scanorama" feature on the air-sea rescue of Tintin and the others from a dinghy in the Celebes Sea, perilously close to the erupting volcano, at the adventure's denouement. Hergé's sudden and dramatic transition from the moment before rescue to the spectacle, thousands of miles away, of the Waggs in front of their television is as successful as it is unexpected. Once again Wagg features at the end of an adventure – as he does in four of the five full adventures we find him in.

Fiction becomes reality. "The Jolly Follies", the folklore group invented by Hergé for *Tintin and the Picaros*, appear at the 1995 carnival at Wavre, Belgium.

## VALIANT REVELLERS

In the final completed adventure, *Tintin and the Picaros*, it is thanks to Wagg's appearance out of the blue with his coachload of "Jolly Follies" at Alcazar's forest hide-out that the General, with Tintin's tactical and moral guidance, is able to carry out his coup and topple Tapioca in the story's closing pages. For the tropics, his kit is predictably loud: a bright red

short-sleeved Hawaiian shirt with a bold white flower pattern, white shorts and linen cloth cap. There are no braces this time, but one can be sure that a belt is holding up his shorts. Like a true tourist, he has a camera and bag slung across his neck and shoulder. He stands out for his brashness, even among his own group of flamboyant, necessarily vulgar carnival performers.

Left behind with a hangover at the camp with the other 'Jolly Follies' as Alcazar takes their coach and costumes to stage his coup in Tapiocapolis, he stands absurdly amid the lush vegetation in pale blue pyjamas and carpet slippers, his normally overgroomed hair all awry. It is noteworthy that his caution – in this case against catching a chill – extends to wearing a vest underneath his pyjamas in the tropics.

He is, however, soon back to his ebullient self and accoutred in his holiday gear to arrive with his group and the forceful Peggy, Alcazar's unprepossessing spouse, at the presidential palace just after Tapioca has been deposed. The new dictator Alcazar can afford to be generous: "Senor Wagg, allow me to express the deep gratitude of the San Theodorian people for the help you have given to our cause. I therefore appoint you and your Jolly Follies to the order of San Fernando, and invite you to next year's carnival." To which Wagg raises his cap and declares: "Good old Alcazar! Give him a big hurrah!" This final finished picture, like the first 20 years earlier, is one of bumptious bonhomie born of a massive inferiority complex and deep insecurity, it hardly needs a psychiatrist to confirm.

**FINAL BANTER**

There is a postscript, a last brief part for Wagg, grinning as usual and sporting his bow tie, in the sketched out *Tintin and Alph-Art* where, after a long interval, he returns to Marlinspike just after the Thom(p)sons and Haddock have been made fools of by Abdullah's exploding cigars: "Aha, exploding cigars! They were a speciality of my Uncle Anatole. Them and the dribbling glass …" He then spots the sculpted 'H' that Haddock has bought and is having to explain to all and sundry to his great irritation. "My, my, what's that thingummy? Looks like an H, eh?" He then asks what it is for – the question calculated to annoy Haddock most – and is offended at the answer: "It is a work of art. It is Alph-Art. It is by Ramo Nash and it is for absolutely nothing at all." At which point a perplexed Wagg makes his final exit from the adventures. ▮

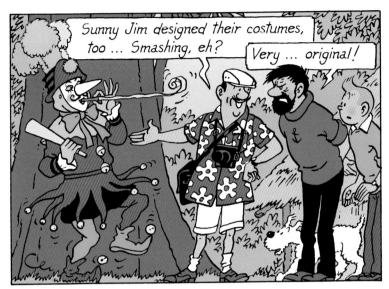
Frame from *Tintin and the Picaros*.

Detail from *Tintin and Alph-Art*.

# General
# ALCAZAR

Kitted out in full military fig or on stage in a knife-throwing act, Alcazar is a typical die-hard Latin revolutionary, bombastic and scheming but with a weak streak.

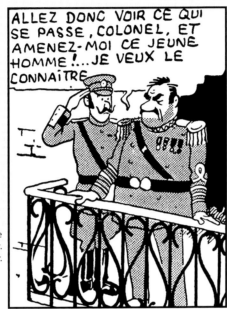

The first appearance of General Alcazar. Frame from *The Broken Ear*.

General Alcazar, the enduring revolutionary with the constant five (or more like seven) o'clock shadow, is an old and not altogether desirable friend of Tintin, "amigo mio." Tintin's first meeting with the irascible South American general could not have been more dramatic. Facing a firing squad on trumped up charges of being a terrorist, Tintin, hopelessly inebriated on the local brandy aguardiente, shouts, "Long live General Alcazar!" as the soldiers take aim. At that very moment the revolutionaries storm the prison yard, the coup is completed and a more than tipsy Tintin is hailed as a hero to be carried shoulder high to General Alcazar, the new San Theodorian leader. This memorable introduction comes as early as 1935 in *The Broken Ear* (published in book form two years later).

**A REVOLUTIONARY ROGUE**

Forty years on, Alcazar is still a revolutionary in *Tintin and the Picaros* (1976), plotting and staging a coup against his resilient old rival General Tapioca.

Times have changed, though not Alcazar himself, apart from his acquisition in the meantime of a battleaxe of a wife, the appalling Peggy, and – a sure sign of middle-age – his need for reading glasses on the final page. His hair too is longer, as one might expect in the 1970s. Otherwise, he still has a short temper, remains a poor loser and continues to enjoy his cigars.

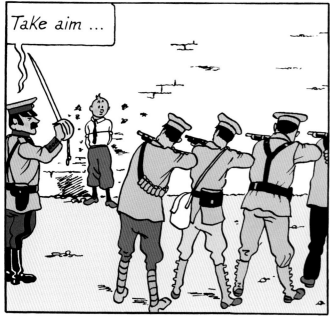

Take aim ...

Stop! Don't shoot!

## A HISTORY OF COUPS

Hergé has in the meantime absorbed as models the Tupamaros guerrillas and, of course, the ultimate revolutionaries, Che Guevara and Fidel Castro in Cuba. Photographs of Castro and his guerrillas in the jungle before he swept to power inspired the scenes showing Alcazar with his men in their rainforest hide-out. Between the adventures, Hergé had gathered material on the Argentinean General Juan Domingo Perón, born in 1895, who led coups in 1942–44 and became president in 1946 before being toppled and exiled in a revolution in 1955. The parallels with Alcazar are obvious even though Hergé's character began his revolutionary activity before Perón and continued it longer. As in several other adventures, Hergé's grasp of current affairs allowed him to anticipate world events remarkably. Hergé did not, however, turn to Perón's glamorous and ambitious wife Eva as a model for Alcazar's spouse, Peggy. Eva Perón, First Lady of Argentina and second wife of General Perón, inspired a huge following but died of cancer in 1952, aged only 33, breaking a nation's heart. Her body was embalmed and kept on display until the 1955 military coup that ousted her husband. Hergé instead based the dreadful Peggy on an American Ku-Klux-Klan spokeswoman he saw on television and sketched immediately.

Hergé also gathered material on the 1960s military dictatorship in Brazil and, most pertinently, General Augusto Pinochet's bloody coup in Chile in September 1973 that overthrew the democratically elected government of President Salvador Allende. In Argentina, there was the coup of 1976 supported by General Leopoldo Galtieri, who came to head the military junta and in 1982 provoked war with Britain by invading the Falkland Islands, resulting in his defeat and downfall followed by a return to democracy.

Long live ... er long live General Alhambra ... no... General Alcazar ... Long live General Alcazar!

Frame and details from *The Broken Ear*.

Detail from *The Seven Crystal Balls*.

Meanwhile in Central America, Hergé observed further revolutions unfold according to the pattern outlined in *Tintin and the Picaros*. In Nicaragua the dictator Anastasio Somoza was toppled by Sandinista guerrillas led by Daniel Ortega in July 1979, while in El Salvador in October of that year, reform-minded officers staged an ultimately unsuccessful coup that led to civil war and the rule of a military junta under José Napoléon Duarte.

### FROM ZARATE, MUSIC HALL KNIFE-THROWER, TO …

Between the first and last Tintin South American adventures Alcazar is not forgotten but, in *The Seven Crystal Balls* and *The Red Sea Sharks*, he is at the wrong end of coups that have sent him into exile and left his rival General Tapioca in power in San Theodoros. So Tintin is astounded to find him engaged as a music hall knife-thrower (of some skill) at the start of *The Seven Crystal Balls*. The stage manager announces: "It is our pleasure to bring to you the world-famous knife-thrower Ramon Zarate!" Tintin thinks: "Haven't I seen that face somewhere before? …" He borrows Captain Haddock's opera glasses: "Great snakes! It's General Alcazar!" They then visit a startled Alcazar in his dressing room: "Caramba! … Tintin! … My old friend!" Over glasses of aguardiente, he observes: "You are surprised to see me tonight on the music hall stage, no? … There is another revolution in my country … and that mangy dog, General Tapioca, has seized power. So, I must leave San Theodoros. After I try many different jobs, I become a knife-thrower."

### … ALCAZAR, A MAN IN A HURRY

Their next encounter – at the start of *The Red Sea Sharks* – is even more fortuitous. Tintin and Haddock are leaving the cinema talking about the western they have just seen. Tintin observes that the lead actor reminds him of Alcazar, and Haddock finds the film's outcome too improbable: "It's as if I was thinking of … I don't know, someone or other … For example, take General Alcazar, whom you mentioned just now. He completely vanished from our lives years ago … Well, d'you suppose, if I just think about him he'll pop up on the street corner, like that, bingo!?" And CRASH Haddock collides heavily with a man: "Look here, you misguided missile, you! Can't you watch where you're going?" "It's GENERAL ALCAZAR!" Tintin exclaims and the general declares: "Caramba!"

Detail from *The Red Sea Sharks*.

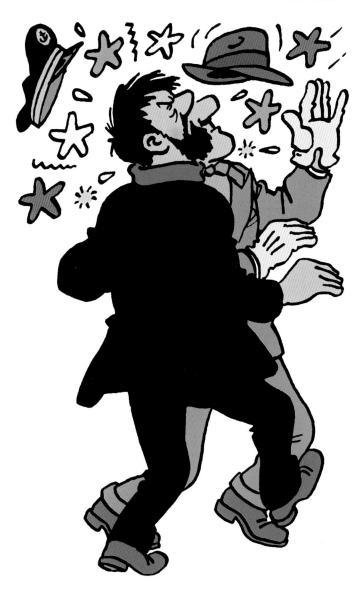

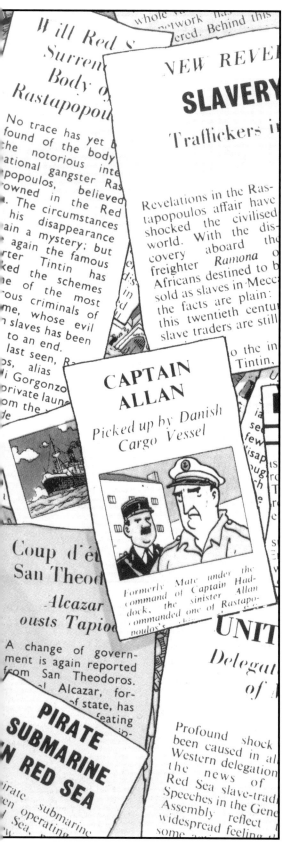

Frame from *The Red Sea Sharks*.

This time, once more in exile, Alcazar is in Europe in search of arms to mount another coup against Tapioca. His contacts with shady arms dealers – in this case the unscrupulous Dawson first encountered in *The Blue Lotus* – account for his reticence on encountering his old friend. Tintin tracks Dawson's "business" to the outskirts of town, sees a Mosquito fighter-bomber parked outside a shed and overhears one of his men ask: "Any news from Alcazar?" Dawson replies: "It's in the bag! Twelve Mosquitoes there, too. To help him chuck out his rival, General Tapioca ..."

Then, at the end of the adventure, among the pile of press cuttings announcing the restoration of power to Emir Ben Kalish Ezab in Khemed and the ramifications of the exposed slavery racket, is a stray article reporting a coup d'état in San Theodoros: "Alcazar ousts Tapioca. A change of government is again reported from San Theodoros ..."

## SATIRE AND HUMOUR

Apart from serious political satire, Hergé's depiction of Latin American dictatorships is full of humour: the operetta uniforms, the San Theodoran army which, in *The Broken Ear*, boasts 3,487 colonels, to the list of which Tintin is added, and only 49 corporals. The very names of the generals are comic: Alcazar, as in a Spanish fortress, his rival Tapioca, like the pudding grains prepared from cassava, and the Nuevo-Rican leader Mogador, reminiscent of a sleeping pill. The heroic full-length statue, sword in hand, of "General Olivaro, Libertador de San Teodoro, 1805–1899" outside the presidential palace is Hergé's tribute to Simón Bolivar (1783–1830), who liberated from Spanish dominion Columbia, Venezuela, Ecuador, Peru and, named after him, Bolivia, the model for the fictional San Theodoros.

Detail from *The Broken Ear*.

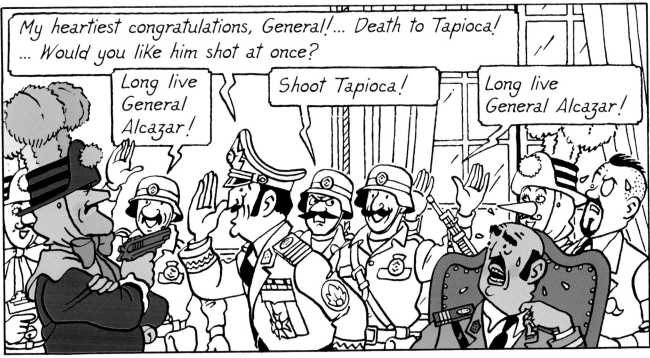

Frame from *Tintin and the Picaros*.

Detail from *Tintin and the Picaros*.

## ALCAZAR, A MAN OF STEEL IN ... A PINK APRON

Except in his private life, where he is all sweetness and submission to the fearsome Peggy – calling her in saccharine tones "palomita mia", his dove, Alcazar with his iron handshake has all the ruthlessness of the Latin American revolutionary/dictator. Opposition is dealt with by the firing squad. In *The Broken Ear* when he is falsely made to believe that Tintin is a traitor, he signs an order for his execution: "He will be shot at dawn tomorrow." After Tintin is liberated from prison during the night, Alcazar is woken up and commands from his bedside telephone: "Recapture him, or I'll shoot every guard at the prison!"

Mercy is not a word in his bombastic vocabulary. When at the jungle camp in *Tintin and the Picaros* the reporter tries to elicit an undertaking from the guerrilla leader that in return for his help there should be no killing, he gets a shocked, incredulous response. "WHAT? You're crazy! ... Or else you're a traitor ... and ought to be shot here and now! ... A revolution without executions? ... Without reprisals? ... Caramba! ... It's unthinkable! ... You must be joking! ... And anyway, what about tradition? ... No, what you ask is impossible, amigo ... Tapioca and his ministers are bloody tyrants and villains ... They must be shot!" But the hopeless drunkenness of his guerrillas compels Alcazar to accept Tintin's conditions. "D'you realise I'll be nothing but a figure of fun if I do as you say?" pleads Alcazar who, a couple of pages earlier, was forced by his domineering wife into doing the dishes wearing a pink frilly apron. He is clearly concerned about the effect of leniency on his macho image as a revolutionary leader.

The Gran Chaco oil fields, disputed by Bolivia and Paraguay in the war of 1932–35.

## INTERNATIONAL OIL INTERESTS

When Hergé decided to send Tintin on the first of altogether four Latin American adventures, he had in mind as background the bloody conflict of 1932–35 between Bolivia and Paraguay over the Gran Chaco oil reserves that cost some 100,000 lives. So he devised the fictional San Theodoros and Nuevo-Rico (a play on *nouveau riche*) respectively and a dispute, fuelled as in reality by rival American and British interests, over the Gran Chapo (sounding in French like 'big hat', suggesting the Spanish *sombrero*) oil fields.

## DICTATORS OF THE SAME FEATHER

International interests continued to play a role in the final South American adventure. Abundant supplies of Loch Lomond whisky are parachuted to Alcazar's guerrillas to incapacitate them through alcoholism and prop up the Tapioca regime, which, moreover, draws on the expertise of a military adviser, Colonel Esponja, already known to readers as Colonel Sponsz in *The Calculus Affair*. Sponsz here is reminiscent of the old Nazis who fled to South America for new lives in the sun following Germany's defeat in 1945. The presence of the former Bordurian secret police chief and the ubiquitous emblem of Kûrvi-Tasch, echoing the fictional East European dictator's extravagant moustache, whether on police armbands, helmets or motor car number plates, demonstrates the extent of Bordurian involvement in San Theodoran affairs. Alcazar, for his part, is supported by the International Banana Company. The uniforms, notably the caps and "coal-scuttle" helmets, worn by members of Tapioca's security services bear a marked resemblance to those

A rogues' gallery of Latin American dictators.

Juan Perón

Alfredo Stroessner

Fidel Castro

Tapioca

Alcazar

Chilean soldiers mounting guard outside the wrecked presidential palace in Santiago after the military coup of September 11, 1973.

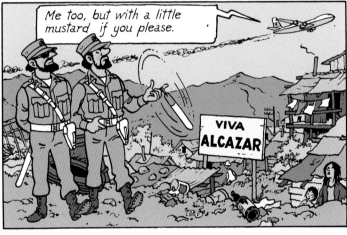

Frames from *Tintin and the Picaros*.

in General Pinochet's Chile. The more informal battle fatigues and caps of Alcazar's adherents are Cuban-inspired. Alcazar and Tapioca are Latin American dictators moulded in the blood-soaked tradition of Perón, Pinochet, Galtieri, Somoza, Duarte, Castro and Ortega; a 20th century rogues' gallery either noted or anticipated by Hergé – and confronted by Tintin in his adventures. Hergé consistently scorned and satirised such desperate and dangerous dictators. By creating Alcazar, who first appears in comic opera uniform in *The Broken Ear* and returns to power 40 years later amid heavy irony through a carnival coup in *Tintin and the Picaros*, he makes their cruelty, ambition and vanity seem ridiculous. The slums or *barrios* patrolled by riot police remain at the end of the adventure under Alcazar, just as they were to be found under Tapioca at the beginning. Only the uniforms have changed. ▮

Anastasio Somoza

Augusto Pinochet

José Napoleón Duarte

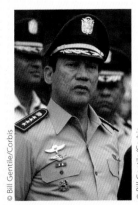

Manuel Noriega

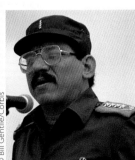

Daniel Ortega

# Dr MÜLLER

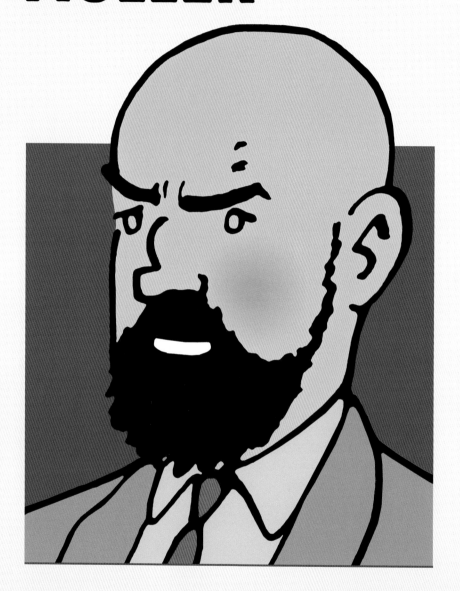

# Violent and dangerous, enterprising and unscrupulous, he is the very personification of evil.

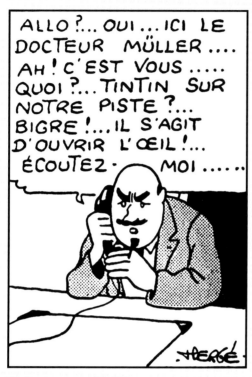

ALLO?... OUI... ICI LE
DOCTEUR MÜLLER ....
AH! C'EST VOUS .....
QUOI ?... TINTIN SUR
NOTRE PISTE ?...
BIGRE !... IL S'AGIT
D'OUVRIR L'ŒIL !...
ÉCOUTEZ. MOI .....

The first appearance of Dr Müller.
Frame from *The Black Island*.

C reated in the climate of fear between the two world wars, it is not surprising that one of Hergé's more durable villains, and one of Tintin's most formidable opponents, was a German. On his first appearance in *The Black Island* (1937), Dr J.W. Müller is a fifth columnist very much in the tradition of a John Buchan thriller, but he was also inspired by a particularly sinister Nazi double agent Hergé had read about.

Cover of the February 1934
special issue of *Crapouillot*.

## BASED ON A CERTAIN DR BELL

Dr Georg Bell was a Nazi troublemaker of Scottish descent whom Hergé had found in the February 1934 issue of *Crapouillot*, an important source of information for him at the time (he had culled material on clandestine arms deals in South America from it for his previous adventure, *The Broken Ear*). Bell was linked at the highest levels with the Nazi party and involved in a plot to destabilise Soviet Russia through counterfeiting Russian roubles. Hergé had the ingredients for his next adventure. Aware of contemporary cinema, he had also been struck by Alfred Hitchcock's 1935 adaptation of John Buchan's novel, *The Thirty-Nine Steps*.

Frame from *The Black Island*.

The work of Dr Bell and his confederates: forged rouble Soviet bank notes, all with the same serial number.

Frogmen recover counterfeit Sterling bank notes, forged by the Nazis, from the bottom of the Toplitzsee in Austria.

At the close of *The Black Island*, Hergé has a newspaper front page reporting the unmasking of the international gang of counterfeiters and illustrating a selection of the currencies forged, including Bank of England notes.

In fact, there was a Nazi plan to destabilise Britain and precipitate economic collapse through the introduction of a large number of perfectly forged Bank of England notes. Although some spies are thought to have been paid in such counterfeit currency, the full plan was never implemented. Years after the end of the Second World War, carefully wrapped and crated bundles of these banknotes were recovered from the bottom of the Toplitzsee in the Salzkammergut region of Austria where the hoard is believed to have been dumped, together with treasures stolen by the Nazis.

"Georg Bell – he claimed his forbears were Scots – was a secret agent and a forger," according to Sefton Delmer, the *Daily Express* Berlin correspondent who met him in 1931. "Under orders from the Reichswehr's Secret Service – so he boasted to me – he had counterfeited five-pound Bank of England notes, French francs, and American dollars after the (1914–18) war. Most recently he had been forging Soviet ten-rouble notes, as part of an operation for the overthrow of the Bolshevik regime." In *The Black Island* (1938), Hergé locates Müller, the counterfeiter and spy based on Bell, in England and Scotland and has Tintin pursuing him and being himself pursued in an exhilarating chase north similar to Richard Hannay's in the Buchan/Hitchcock thriller.

Frames from *The Black Island*.

## HERGÉ, HITCHCOCK AND BUCHAN

While Hergé knew the Hitchcock film, there is no concrete evidence that he read Buchan's 'yarn'. Yet details from the novel occur in the Tintin adventure but not in the film. When Buchan's hero Hannay is hiding, having escaped from the archaeologist's mansion (the equivalent of Müller's imposing house), he notices a concealed airfield for the villain's aeroplane. Making his getaway, he avoids a trip wire which would have rung a bell in the house – as happens to Tintin in the grounds of Müller's manor when he steps on a man-trap setting off an alarm. Buchan's German spy ring the "Black Stone" – not alluded to by Hitchcock – could also have had a bearing on Hergé's "Black Island". Unlike Buchan and Hergé, Hitchcock makes little use of aeroplanes, with only a primitive helicopter hunting Hannay. Hergé, however, picks up ideas from Hitchcock absent in Buchan. In the first edition of *The Black Island* he depicts *The Flying Scotsman*, which had recently become the first steam locomotive to record a speed over 100 mph. Hitchcock films the magnificent locomotive pulling out of London. The film departs from Buchan by inserting a romantic element and having Hannay, played suavely by Robert Donat, handcuffed to the alluring blonde, Madeleine Carroll. There are no women or handcuffs in the Buchan original, but Hergé uses the idea when Tintin manacles the Thom(p)sons to each other with comic consequences.

Poster for Alfred Hitchcock's film *The 39 Steps*.

## CINEMATIC METHODS

For Hergé, who during the 1930s was increasingly interested in applying cinematic methods and techniques to the art of the strip cartoon he was developing, there were lessons to be learned from Hitchcock's early tour de force, not least the fast-paced narrative with its rapidly changing scenes.

## THE CENSOR

During the German occupation of Belgium from 1940 to 1944, *The Black Island*, together with *Tintin in America*, were the only Tintin adventures banned from publication – the former because it unfolds in Britain, the latter because of its American setting. The fact that the British adventure had a particularly unpleasant German villain appears to have been over-looked. The German censorship also passed over *King Ottokar's Sceptre* with its fascist villain Müsstler – a hybrid of Hitler and Mussolini – and *The Blue Lotus* with its savage indictment of the imperialism and militarism of Japan, Nazi Germany's ally in Asia.

Hergé had re-introduced Müller as the villain in the adventure he was working on at the time Nazi tanks rolled into Belgium and occupied Brussels in May 1940. This was the opening of *Land of Black Gold* with its tale of a German plan to sabotage the oil supplies of other countries and thus paralyse their military capability. He had begun the adventure on the eve of the opening of hostilities in September 1939. During the months of the so-called 'phoney war' he continued it in the pages of *Le Petit Vingtième* until Brussels fell and the newspaper was closed down by the German authorities.

Cover illustration, *Le Petit Vingtième*, February 15, 1940.

Cover illustration, *Le Petit Vingtième*, May 9, 1940.

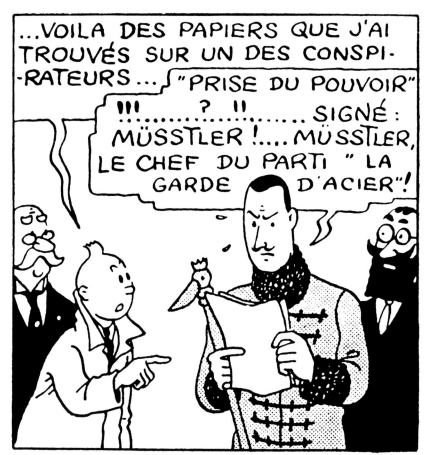

Frame from *King Ottokar's Sceptre*.

## EIGHT YEARS IN THE DESERT

At the moment of interruption, the merciless Dr Müller decides to save a bullet and instead dumps an unconscious Tintin, bound and gagged, in the midst of the desert to face apparently certain death in a ferocious sandstorm, the simoom. "And now let the sandstorm do its work," Müller declares as he lets Tintin's limp body drop from the saddle. However, it clearly was no longer wise to have a German villain and to be echoing current affairs, so Hergé decided to shelve the incomplete adventure and instead, when he was offered the opportunity to continue Tintin in the pages of *Le Soir Jeunesse*, he started anew on the politically neutral *The Crab with the Golden Claws*, notable for the introduction of Captain Haddock.

Eight years later, with Nazi Germany defeated and Hergé working again, he could return to the suspended adventure with its German villain and, adding new characters such as Captain Haddock and Professor Calculus, bring *Land of Black Gold* to its conclusion.

## AN AGEING MÜLLER

Picking up where he left off, Hergé cuts and modifies the sequence where Müller leaves Tintin to his desperate fate. Instead of carrying Tintin off and dumping him in the desert, the villain hears the Thom(p)sons jeep approaching and decides to make a quick getaway. The Müller that Tintin encounters has aged – a rare development in the adventures – since *The Black Island*. He has become completely bald and compensates for the lack of hair on his head with a full beard instead of the moustache and goatee sported previously. He remains most dangerous.

Plates 55 and 56 of *Land of Black Gold*, published in *Le Petit Vingtième* of May 9, 1940.

The invasion of Belgium by German troops on May 10, 1940, prevented the publication of these plates that were intended for the May 16 issue of *Le Petit Vingtième*. The changes that Hergé subsequently made to the narrative resulted in the suppression of this highly dramatic sequence.

Plates 57 and 58 of the first version of *Land of Black Gold*.

Frame from *Land of Black Gold*.

## AS BOGUS ARCHAEOLOGIST

Tintin sees him next in the Emir's palace where, in the guise of an archaeologist, Professor Smith, he tries unsuccessfully to bully Mohammed Ben Kalish Ezab into signing a deal with Skoil Petroleum. His failure leads him to kidnap the Emir's precious but impossibly mischievous son Abdullah. Müller strides out of the palace cursing but fails to notice Tintin in Arab dress, waiting for an audience with the Emir.

## A WELL-DRESSED VILLAIN

Müller has an acute sartorial sense, already evident in *The Black Island* where he possesses a good range of tweed suits. He can, however, make the continental mistake of overdressing, and his predilection for jodhpurs and riding boots is decidedly Germanic. Returning in *The Red Sea Sharks* as Mull Pasha, the foreign commander of Arab forces, he is smartly turned out in khaki uniform with Arab headdress. It is only a brief role – inspired by Glubb Pasha, the British officer behind the Arab Legion, on whom Hergé had cuttings – but it shows how the author liked his villains to return and did not believe in keeping them under lock and key for too long.

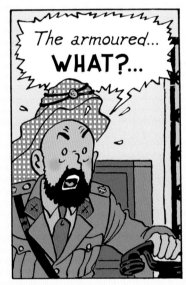

Frame from *The Red Sea Sharks*.

Apart from sharp dressing, Müller reveals his origin with his expletives. His repertoire includes a peppering of: "Teufel!" "Himmel!" and the colourful and less clichéd but highly offensive "Kruzitürken!" – a now little-used southern German swear word derived from "Crusade against the Turks!" or "Crucify the Turks!"

## EVIL PERSONIFIED

It is on such occasions that he most resembles his original model, the obnoxious Georg Bell described so vividly by Delmer. This was a man whom it was not safe to tangle with, as Tintin discovers on more than one memorable occasion. There are few scenes more sinister in any of the adventures than when in *The Black Island* Müller apprehends Tintin and tells him: "It was a mistake to meddle in our affairs. I shall now have to dispose of you. Fortunately, I happen to be a medical superintendent of a private mental institution: rather a special institution. Not all of my patients are insane when they are admitted … but after eight hours of treatment, they are unlikely to recover." The horror of his meaning is truly worthy of Hitchcock.

There can be no doubt; Müller is evil personified. Not for a moment does he have an ounce of that oily affability which can even occasionally be shown by the arch-villain of the Tintin adventures: Roberto Rastapopoulos. ∎

Frame from *Land of Black Gold*.

Frames from *The Black Island*.

# RASTAPOPOULOS

# A tycoon whose villainy and vanity knows no bounds, the sworn enemy of Tintin.

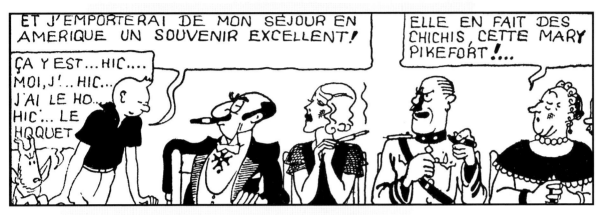

The first appearance of Rastapopoulos with monocle and cigar, sitting next to the actress Mary Pickford, alias Mary Pikefort. Frame from *Tintin in America*.

Mary Pickford in 1921.

Tintin has one enemy whom, it must be feared, might one day get the better of him: Roberto Rastapopoulos. His tentacles reach wide, his corruption is corrosive, his wealth immense and his powers of escape are remarkable. While Sherlock Holmes found his match in Professor Moriarty, by far his most dangerous opponent, and might have met his end at the Reichenbach Falls in Switzerland, Hergé, who knew the Conan Doyle stories, made Rastapopoulos play Moriarty to Tintin's Holmes. It is an enthralling duel and the end remains uncertain. Throughout the adventures, Snowy, with his dog's wisdom, warns his master against "playing Sherlock Holmes."

**THE MOGUL BEHIND COSMOS PICTURES**

Our first glimpse of Rastapopolous is at the banquet given in Tintin's honour towards the end of *Tintin in America*. It is hardly surprising that a film mogul, as we learn Rastapopoulos to be in the subsequent adventure, *Cigars of the Pharaoh*, should sit next to the celebrated actress Mary Pickford (or Mary Pikefort, according to Hergé's original guest list). The American actress became the first star of the silent screen to be known by name, and on her marriage to Douglas Fairbanks senior in 1920, they were dubbed 'the world's sweethearts.' In the early black and white version of *Cigars of the Pharaoh* they are possibly the models for the lead roles in the Cosmos Pictures desert drama, although screen idol Rudolph Valentino, famed for his handsome lover roles in *The Sheik* and *Blood and Sand*, can also stake a strong claim.

Rudolph Valentino, ready for star billing with Cosmos Pictures?

This gentleman didn't bump you on purpose.

Goodbye, everybody!

Frames from
*Cigars of the Pharaoh.*

But what are you doing here, all by yourself in the middle of the desert? Come and explain...

Certainly...

Tintin's next encounter with the tycoon is aboard the M.S. Isis on which the reporter had been hoping for a quiet, relaxing cruise after the exhausting American adventure. The absent-minded, if not unhinged, Professor Sophocles Sarcophagus barges into a fellow passenger on deck mistaking him for a ventilator. "Imbecile!" cries the furious human buffer, threatening to strike the scholar. Tintin intervenes. "Impudent young whippersnapper! How dare you interfere? You obviously don't know who I am. One day you'll regret you crossed my path! ... Just remember: my name is Rastapopoulos!" The angry filmmaker storms off and Tintin thinks: "Ah! I've got it: the millionaire film tycoon, king of Cosmos Pictures ... And it's not the first time we've met ..."

It is a very different Rastapopoulos that Tintin meets later at his desert film studios. Tintin has blundered into the filming of a scene of his latest spectacular on hearing the well-rehearsed screams of the leading lady being flogged by two Arabs. The film crew are furious at the interruption but not Rastapopoulos who enters and is all affability. This is the alternate, oily side of the tycoon that, at least on this occasion, takes Tintin in. Elsewhere, others are fooled by his charm, none more than Bianca Castafiore with whom he is for a time romantically linked.

Rastapopoulos invites Tintin into his tent and, over a pot of Turkish coffee, the reporter, little suspecting that it is the film mogul who has been seeking his demise, tells him all.

Frames and detail from *Cigars of the Pharaoh*.

## FALSE CONFIDENCE

The idea of being mistakenly trustful of the villain, taking him into one's confidence as Tintin does, lends a particularly chilling twist to the adventure and was one favoured at the time by thriller writers such as John Buchan. He inspired the film director Alfred Hitchcock who in turn influenced Hergé. Next, having escaped from the gun-runner and the Thom(p)sons seeking his arrest, Tintin returns to report back to Rastapopoulos. He finds the magnate and gains a suitable response: "My dear chap, it's exactly like a film. Anyone would think there was a plot to get rid of you!" Tintin spends the night as the guest of the tycoon who sees him off the next morning with a hollow "Good luck!"

Although Tintin and readers only ever get a back view of a trench-coated figure wearing a hat, it is indeed Rastapopoulos who reappears at the end of *Cigars of the Pharaoh* having with the fakir kidnapped the crown prince of Gaipajama. A high-speed car chase along the narrow, winding Himalayan mountain roads ensues, with Tintin at the wheel of the Maharajah's racing Bugatti. Abandoning the cars, a Holmes/Moriarty type struggle follows amid the rocky crags until the mysterious adversary slips and plunges to his apparent doom in a denouement strongly reminiscent of that devised by Sir Arthur Conan Doyle. A newspaper cutting at the bottom of the page reports the freeing of the royal hostage and Tintin's bust of the drugs gang has a shorter news item alongside. The fragment is headlined "Cosmos King Vanishes" and has a Cairo dateline: "Speculation grows here over the fate of millionaire film magnate Rastapopoulos reported missing yesterday from his desert camp". It is, of course, the first of a number of disappearing acts and escapes from justice perpetrated by the most indestructible villain among the cast of *The Adventures of Tintin*.

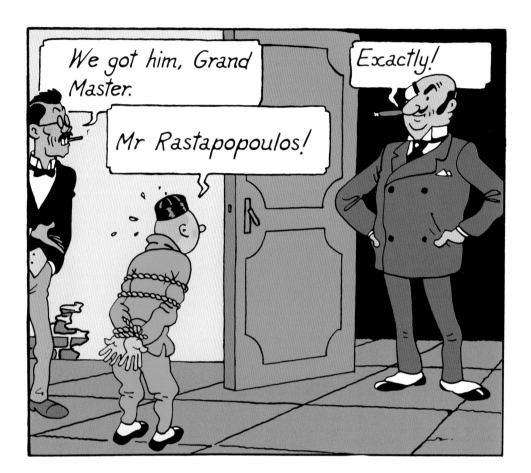

Frames from *The Blue Lotus*.

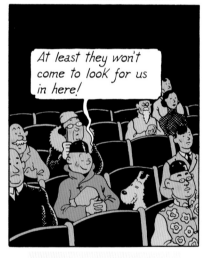

## THE RETURN OF RASTAPOPOULOS

Rastapopoulos returns in the subsequent adventure, *The Blue Lotus*. Tintin flees the British soldiers pursuing him in the International Settlement in Shanghai by diving into a cinema. Suddenly he is surprised by a trailer for the latest Cosmos Pictures production showing the very scene of the two Arabs maltreating the European blonde which so outraged him when he witnessed its filming in the desert. On the next page Tintin is amazed to learn that Rastapopoulos is in Shanghai at the Palace Hotel. There he startles the tycoon, comfortably attired in smoking jacket lighting up a Havana. "Tintin! What a pleasant surprise!" flusters the tycoon. Tintin, still trusting Rastapopoulos as at their last meeting in the desert, explains that he is trying to track down the missing Professor Fang Hsi-ying who was last seen with the millionaire. "Yes, quite right. I gave the professor a lift in my car ... Why do you ask?" responds Rastapopoulos, feigning ignorance of the abduction he has engineered.

The reporter's illusions, however, are forever shattered when Rastapopoulos is finally revealed by the horribly sinister Mitsuhirato to be none other than the "Grand Master" of the drug ring. Rastapopoulos stands resplendent in the doorway, strikingly dressed as usual, cigar in mouth, glaring at Tintin through his monocle. "Alive and well ... And as always, coming out on top," he gloats in triumph.

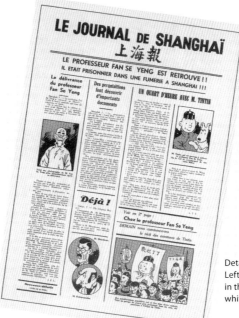

Details from *The Blue Lotus*.
Left, *Le Journal de Shangai*
in the original black and
white version.

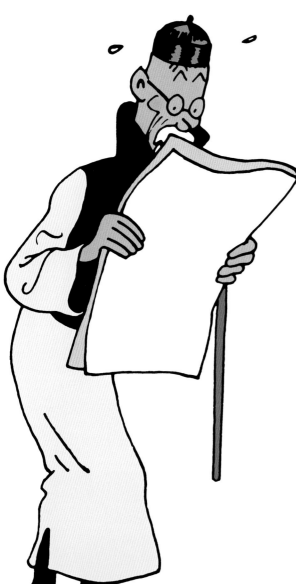

Tintin, aided by Chang, soon manages to turn the tables on his adversary, but Rastapopoulos is far too slippery a criminal to be put out of harm's way for long. The Shanghai News reporting the wrapping up of the affair informs its readers that the international gang of drug smugglers uncovered by Tintin were "now all safely in police custody." However, the full front page given over to the matter in Le Journal de Shanghai in the original black and white French version, has further information, confirming, as his name suggests, that Rastapopoulos is "a Greek subject" suspected of drug smuggling and illicit arms dealing and wanted by the legal authorities of no less than 17 countries.

According to Hergé, a friend invented the name Rastapopoulos that he found so amusing and felt he had to use. As a villain, Hergé saw him as being fat and indolent but no means less dangerous than the more energetic Dr Müller.

## A REAL MODEL, ANOTHER GUISE

Following his arrest at the end of *The Blue Lotus*, readers had to wait 22 years for Rastapopoulos's reappearance in *The Red Sea Sharks* (1958) by which time Hergé had found a real model for his dangerous Greek billionaire: Aristotle Socrates Onassis, who amassed a fortune constructing supertankers and became legendary for his wealth and display of it – notably his palatial yacht *Christina*. On such a yacht, the Scheherazade, we recognise Rastapopoulos, thinly disguised as the Marquis di Gorgonzola, making his comeback. Like Onassis, he is surrounded by his celebrity friends, a princess here, a world-famous soprano there. Described in the words of the sailor rowing Tintin and Haddock to the yacht: "And what a bunch they are: high society. I can tell you: nothing but dukes, duchesses and film stars – all the nobs."

Frame from *The Red Sea Sharks*.

Aristotle Onassis, who became the model for Rastapopoulos.

Earlier, Tintin learned of the "infamous di Gorgonzola ... shipping magnate, newspaper proprietor, radio, television and cinema tycoon, airline king, dealer in pearls, gun-runner, trafficker in slaves ... international crook." His ranking as top villain in *The Adventures of Tintin* is demonstrated by his authority over Mull Pasha – the formidable Dr Müller in Arab employment – who reports directly to him on his efforts to eliminate Tintin and Haddock.

## SUCH IS THE PHOENIX

Finally cornered by the U.S.S. Los Angeles and facing arrest, a desperate Rastapopoulos orders engines to be stopped: "I'll go myself and tell those insolent cowboys what I think of their manners!" He dons a yachting cap and boards his motor launch. Steering towards the cruiser he then brings off a ruse worthy of Moriarty as the launch suddenly sinks and disappears. Only the reader sees the redoubtable Rastapopoulos slip away in a midget submarine that has shed its outer casing like a moth leaving the chrysalis. Hergé follows this with his favoured device of a cluster of press cuttings reporting the denouement of the adventure. According to one: "No trace has yet been found of the body of the notorious international gangster Rastapopoulos, believed drowned in the Red Sea. The circumstances of his disappearance remain a mystery". Readers, of course, know better: Rastapopoulos, the man with no morals, has escaped to continue a life of crime and resume at a later date his duel with Tintin.

Frame from *The Red Sea Sharks*.

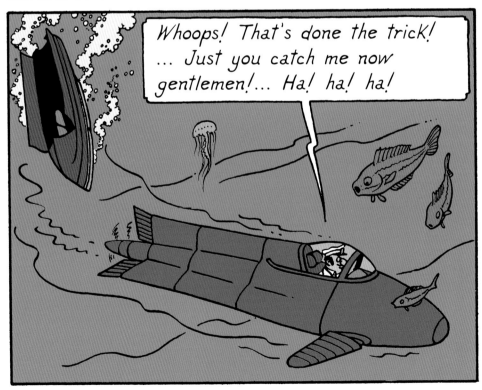

## THE VILLAIN AS BUFFOON

A decade and three adventures later in *Flight 714 to Sydney* (1968), Rastapopoulos resurfaces, looking ridiculous in full cowboy kit, as the organiser of the hijacking of the Carreidas 160 supersonic executive jet with its billionaire owner Laszlo Carreidas. In this new adventure Rastapopoulos remains, in his own words, "the devil incarnate" but like his extravagant cowboy costume with its elaborately buttoned and pocketed pink shirt he has become absurd, from the moment he tries – unsuccessfully – to "crush an insignificant spider." Thirty-five years after his debut in the adventures, Rastapopoulos has grown into more of a buffoon than an evil genius.

## A PATHETIC FIGURE

Hergé decided that the time had come for the humiliation of Rastapopoulos and his longstanding lieutenant, the despicable bully Allan Thompson. "During the story, I realised that when all was said and done Rastapopoulos and Allan were pathetic figures. Yes, I discovered this after giving Rastapopoulos the attire of a deluxe cowboy; he appeared to me to be so grotesque dressed up in this manner that he ceased to impress me. The villains were debunked: in the end they seem above all ridiculous and wretched. You see that's how things evolved … Thus undone my villains appeared to me a little bit more likeable. They are rogues, but poor rogues," Hergé told Numa Sadoul. It was not the first time Hergé chose to make a fool of the villain. There was the moment towards the end of *Land of Black Gold* when Müller rather than surrender decides to blow his brains out but – given a trick pistol by Abdullah – only manages to cover his face in black ink.

## TELLTALE CLUES

Hergé's introduction of Rastapopoulos in *Flight 714 to Sydney* is typically mysterious. The reader has back views of a man in a cowboy hat next to another wearing a naval cap. Similarly, readers saw only the back of a figure in trench coat and hat in the mountain chase at the end of *Cigars of the Pharaoh*, leaving them to guess his identity. Here a telltale black cord hanging by the cowboy's cheek suggests Rastapopoulos's monocle to the discerning reader. Hergé then uses another favoured device – voice recognition. An unseen figure barks out a command and Tintin thinks: "That voice!?" And in the next frame his arch-enemy stands exultant before him in a pose similar to the one near the end of *The Blue Lotus*. "RASTAPOPOULOS" exclaims Tintin.

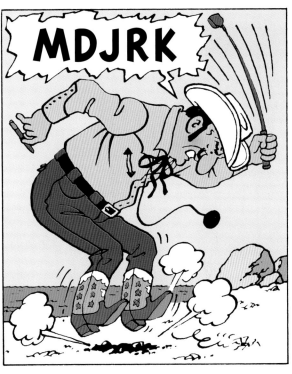

Frame from *Flight 714 to Sydney*.

Hergé at home in his Stetson, 1973.

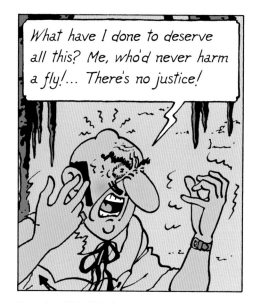

Frame from *Flight 714 to Sydney*.

The Stetson worn by Rastapopoulos is even more impressive than the one he has in *Cigars of the Pharaoh*. Hergé told Numa Sadoul that he was especially proud of it: "I am very fond of his hat. I bought one just like it in the United States, in Rapid City, a small town in South Dakota. It's a magnificent 'Stetson', as hard as wood, impossible to put out of shape." It caps his portrayal here of Rastapopoulos's descent into vulgarity from the vain dandy of the earlier stories. Somehow too this makes him appear less threatening, a development that Hergé would later correct. He is caricatured in this adventure, his frequent, choleric tantrums overexposed, his bald cranium sprouting bumps, his colourful clothing shredded. His exit at the end is more enigmatic than ever as he climbs from a rubber dinghy up a ladder into a spaceship – a rare departure by Hergé from reality, the wisdom of which he later came to doubt.

## THE FINAL COMEBACK

Can this really be the end of Rastapopoulos? There is no place for him in the final completed adventure *Tintin and the Picaros* with its return to a South American setting. However, though shrouded in a good deal of mystery and never formally identified, it is Rastapopoulos, like Moriarty a master of disguise, who stages the ultimate comeback as the luminary mystic Endaddine Akass in Hergé's last, unfinished adventure *Tintin and Alph-Art*.

Detail from *Tintin and Alph-Art*.

Tintin and Haddock decide to attend the "Health and Magnetism" conference given by Endaddine Akass and on hearing the heavily accented voice Tintin thinks: "That voice … Some of his intonations remind me of … of … someone. But who?" Then later on the island of Ischia, Tintin receives an anonymous telephone call in his hotel room warning him to leave or the climate could become unhealthy for him. "Crumbs! … That voice?" As in *Flight 714 to Sydney*, Tintin is on the brink of recognising Rastapopoulos. Among newly rediscovered pages for the adventure is one where Rastapopolous having, in Hergé's own handwritten note, "had an operation of plastic surgery" is revealed to a startled Tintin. On another page of sketches and notes, Hergé has Endaddine Akass describing to Tintin the terrible fate he has in store for him – being cast as a human statue – and behind the fez-like hat, outsize dark glasses, long hair and beard, he has drawn an arrow and ringed in red crayon the name "Rastapopoulos?"

Helsinki Compression by César, 1964.

No longer is Rastapopoulos a figure of ridicule; he is back to his old sinister self as Tintin's arch-enemy: Moriarty seeking his final revenge on Holmes. And who will come out on top?

In the guise of Endaddine Akass, he catches Tintin snooping among his freshly painted forgeries of leading modern artists: "As for you, young man, I'm desperately sorry, but you know too much. You will have to disappear. You know César?" A bewildered Tintin replies: "Er … Caesar … Julius?" "No, just César, the sculptor, the master of compressionism. Look, this is one of his. He's also an expansionist, as in this piece here … Well my friend, we're going to pour liquid polyester over you; you'll become an expansion signed by César and then authenticated by a well-known expert. Then it will be sold, perhaps to a museum, or perhaps to a rich collector … You should be glad, your corpse will be displayed in a museum. And no one will ever suspect that the work, which could be entitled 'Reporter,' constitutes the last resting place of young Tintin … Ha! Ha! Ha!" It is the distinctive cynical laugh of the master villain Rastapopoulos who nearly 50 years earlier had boasted to Tintin in *The Blue Lotus* that he was alive and well and "as always coming out on top." At dawn the next morning a sleeping Tintin is rudely awakened by an armed guard: "On your feet! Get moving! It's time for you to be turned into a 'César' …" he says, marching Tintin off at the point of a pistol. It is the last moment in *The Adventures of Tintin*. ▮

Details from *Tintin and Alph-Art*. Rastapopoulos as Endaddine Akass.

Detail from *Flight 714 to Sydney*.

# INDEX

Note: Entries in **bold** type are fictional characters.